Do the Fucking Work

DO THE FUCKING WORK
Copyright © 2019 by Jason Bacher, Brian Buirge, and Jason Richburg.

All rights reserved. No part of this book may be used or reproduced in any manner whatsoever without written permission except in the case of brief quotations embodied in critical articles and reviews. For information, address Harper Design, 195 Broadway, New York, NY, 10007. HarperCollins books may be purchased for educational, business, or sales promotional use. For information please email the Special Markets Department at SPsales@harpercollins.com.

Published in 2019 by
Harper Design
An Imprint of HarperCollins*Publishers*
195 Broadway
New York, NY 10007
Tel: (212) 207-7000
Fax: (855) 746-6023
harperdesign@harpercollins.com
www.hc.com

Distributed throughout the world by
HarperCollins*Publishers*
195 Broadway
New York, NY 10007

ISBN 978-0-06-288673-6
Library of Congress Control Number: 2019026598

Design by Good Fucking Design Advice

Printed in China

First Printing, 2019

Do the Fucking Work
Lowbrow Advice for High-Level Creativity

Jason Bacher

Brian Buirge

Jason Richburg

An Imprint of HarperCollins*Publishers*

To our parents:

We're sorry.

Contents

Introduction	6
1 Get fucking started.	10
2 Obstacles are fucking opportunities.	50
3 Fail, fail, and fucking fail again.	94
4 Ask for fucking help.	136
5 Show some fucking passion.	172
6 Finish the fucking job.	212
Show some fucking gratitude.	252
About the Authors	254
Index	256

Good Fucking Design Advice.
Because sometimes, being your own worst critic is not enough.

Believe in your fucking self. Stay up all fucking night. Work outside of your fucking habits. Know when to fucking speak up. Fucking collaborate. Don't fucking procrastinate. Get over your fucking self. Keep fucking learning. Form follows fucking function. A computer is a Lite-Brite for bad fucking ideas. Find fucking inspiration everywhere. Fucking network. Educate your fucking client. Trust your fucking gut. Ask for fucking help. Make it fucking sustainable. Question fucking everything. Have a fucking concept. Learn to take some fucking criticism. Make me fucking care. Use fucking spell check. Do your fucking research. Sketch more fucking ideas. The problem contains the fucking solution. Think about all the fucking possibilities.

Brian Buirge + Jason Bacher

Good Fucking Design Advice aims to serve the needs of the greater design community for the common good.

Whether you're a student unable to receive a timely response from a professor, a designer eagerly awaiting feedback from a vacationing art director, or a sheltered freelancer lonely toiling away in her studio apartment, Good Fucking Design Advice will provide you with immediate unbiased assistance 24/7.

goodfuckingdesignadvice.com

GFDA's Classic Advice Print

Read a fucking book.

TL;DR
In September of 2010, two guys named Jason Bacher and Brian Buirge founded a company called Good Fucking Design Advice (GFDA). We are those two guys (and some other guy we'll introduce later), and, after almost a decade of ups and downs, we're sharing what we've learned.

We've spent our careers creating content, merchandise, presentations, and workshops that inject a heavy dose of reality into the creative process – some people sugarcoat the truth; we dip it in hot sauce. What you're about to read (or not read, depending on how this introduction goes) is the sum total of what we've learned from getting hundreds of thousands of people off their creative asses and helping them see their work, and their lives, differently. We've gathered up our most popular advice, and a whole bunch of new advice written just for you, and re-imagined it as a series of visual experiments that we promise will make you smile as well as groan. As a bonus, just to prove that we practice what we preach, we've also shared the story of starting, maintaining, overhauling, resuscitating, and transforming our own brand from a smart-ass website into an international success. We think you'll find it funny, motivational, and *maybe* even a little thought-provoking.

This whole crazy thing started with a website we built in our spare time during grad school (more on that in the following chapter), but our first product, an eighteen-by-twenty-four-inch screen-printed poster, featuring twenty-five pieces of advice, twenty-nine swear words, three colors, and two typefaces, is really what launched us into C-list internet stardom. Since we first introduced it in 2010, the uninhibited message and austere layout of the GFDA Classic Advice Print has resonated with people across industries, demographics, and continents.

We're humbled that our poster hangs in the offices of Apple's chief design officer, Jony Ive, and his senior design team, and that it was read aloud by that baddest of motherfuckers, Samuel L. Jackson, at a tribute to Louise Wilson (who was also a big fan of our advice) during the 2014 British Fashion Awards. It's gotten us press in *The New Yorker*, *Rolling Stone*, *Business Insider*, and *Fast Company*.

It touches our Pantone Warm Red hearts that this simple piece of paper has had such a measurable impact in people's lives. In fact, if we'd never made the Classic Advice Print, we probably couldn't have written this book. (You're welcome.)

Profanely Profound
So let's just go ahead and get the whole f-word thing out of the way right now. A lot of people are uptight about it; some are openly hostile. Our earliest detractors predicted that our use of profanity would set the design industry back ten years. Hopefully we've allowed for an adequate recovery period before releasing this book, because we're going for fifteen this time (fingers crossed).

Rarely are accusations of our crimes against decency ever accompanied by objective criticism of the quality of our work, or a denial that our audience finds meaning in our message. The most valid denunciation of GFDA is that we use profanity to get attention . . . because it's absolutely true. We're lucky to have had so many deeply inspiring friends, mentors, and collaborators, and our exposure to them would have been insignificant if they hadn't shaken us up and challenged our perspectives. We're just trying to reproduce that effect — to challenge your perspectives, to actually

make you stop and think. If one little four-letter word provides the leverage necessary to pry open the eyes, ears, hearts, and minds of a multitude, then ruffling the feathers of a small minority is a fair trade in our estimation. Make no mistake about it, being offended is always a choice.

Not only has every forecast of our inevitable failure proven accurate, but failure has resurrected itself in our careers in a breadth of variety that even our most intellectually superior haters couldn't have predicted. What they never managed to account for, though, is our endurance. Of course we fail constantly. We just don't quit.

We passed our own trial by fire when we started the business and kept it afloat despite endless obstacles and uncountable mistakes. Perhaps even more important than what we accomplished is the unbelievable fun we've had and the friends we've collected in the process. Now, through our workshops, we help other people live their own incredible stories, and accomplish their own crazy goals. Not everyone will start a business, land a *Fortune 500* client, or get a corner office in the C-suite, but we all have ambitions that are absolutely within our grasps.

If the advice we've collected here could be distilled down into its simplest form, it would be: believe in yourself, work hard, enjoy your life, and never fucking give up. If that's all you take away from this book, we've done our job.

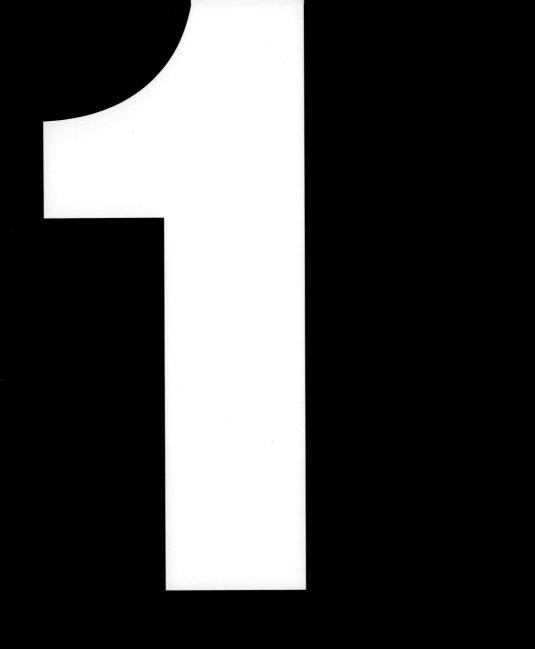

Get fucking started.

From the very beginning of GFDA, following our creative instincts has made our lives substantially more meaningful (and severely more difficult at times). It's commonly misunderstood that the meaning of life is some lost secret or the incalculable answer to a single question and that, if one simply tries on enough roles or arbitrarily travels down enough disparate paths, one day the final stone will serendipitously be turned over and this shiny bauble of ultimate meaning will mysteriously reveal itself. Then, at last, it won't take so much damn effort just to get by. But the meaning of life isn't discovered – it's created. It doesn't ease your burden, but instead inspires you to do more. You have to willfully make life meaningful – every day.

Great Falls Development Authority
We first met in graduate school at Kent State University where we were studying Visual Communication Design (VCD) and instructing students terrifyingly close to us in age. Teaching design can be summed up as the act of reciting the same handful of fundamental principles roughly forty times a day for about fifteen weeks – eventually, this process will wear down even the most glib young professors. The effect is amplified when one's students respond with questions whose answers are those exact same principles that have already been repeated ad nauseam.

Our budding friendship was founded on the modest assumption that we had, between the two of us, solutions to all of the world's problems, and we decided to use our vast intellectual resources to figure out some means of answering our students' tireless questions with as little effort as possible. (Our wholly altruistic motivation being to free up our time to focus on society's more pressing issues.) Instructors often recommend that beginning students compile the design basics into lists in their notes to refer to while they work. We dissected the issue over a cup of coffee, and arrived at our own spin on this idea: curating several design axioms and a few other pieces of insider jargon into a website.

Now, anyone who has ever taught a course, or attended college, or even heard of institutional learning, is at least vaguely aware of the peculiar side effect of spending tens of thousands of dollars on an education that afflicts students with a crippling sense of apathy toward most of their course material and subject matter. That insight begged the question: How do we get people to actually visit this site? After brief but earnest deliberation, we had nothing. So, like anyone else whose ideas have run out, we resorted to profanity. We knew we were offering design advice, and we were confident that it was good, but we still needed a little exotic seasoning to entice the senses of our users. We threw in the f-word and, voilà, a memorable yet ill-advised brand name was born. GFDA.com was unfortunately already taken by an organization devoted to the improvement of Great Falls, Montana. (It's since become available for $65,000. Our current bid is $253, up a dollar from last week.) Shockingly, however, goodfuckingdesignadvice.com was still available, and we shrewdly snatched it up. Since we now had an idea just ridiculous enough to waste an entire day on, we headed back to campus and rolled up our sleeves.

NSFW ASAP
The VCD graduate studio was a sort of wild creative laboratory with no locks on the dangerous chemicals and an unlimited supply of test subjects. It was the perfect place for us to cook up such an unwittingly volatile mixture as GFDA. We immediately began laying out pages and copying and pasting snippets of CSS. Right about the time that we'd set the word "fucking" in 100-pt. Helvetica Bold, a colleague happened to walk by and burst into laughter. We exchanged deviant grins and clicked

Get fucking started.

faster. By 5 p.m. we had churned out just enough code to turn twenty-five pieces of classic design advice into a PG-13 website that would one day be censored by most major corporations.

Our international debut had a relatively limited audience of about thirty Facebook friends and a few Google Analytics bots. We also hung flyers offering "free design advice" around campus with a few of the tear-off tabs (featuring a shortened version of our URL) tactically removed ahead of time. What we saw as a risky but plausibly deniable exercise in juvenile amusement would soon prove to be a life-changing event — thank god we set up those analytics.

Between the coffee and the domain registration, we had only squandered $14.45 and about a day's worth of billable hours (unbeknownst to them, the university library supplied the flyers). Without having any real expectations, we agreed to meet in the studio at midnight to see if our experiment had produced any results.

Miller Time
Just hours after building our website from scratch, we sat in slack-jawed astonishment as the analytics revealed that over 500 people had visited that day. This was vastly more than both of our personal sites had ever received . . . combined . . . cumulatively. We bounced joyfully to the nearby Circle K to celebrate our unexpected accomplishment with some champagne (of beers).

In a demonstration of oaken will, we didn't check the analytics again until the following midnight: over 6,000 visitors and, you guessed it, two more crisp, well-earned 40s. Assuming that our unlikely flash in the pan surely must have burned itself out, we started drinking early on the third night, but our 70,000 visitors sobered us right up. It was time to get to work.

Inconvenience Store
Read. Write. Research. Open an official Twitter account. Attend class. Read some more. Teach class. Make an official Facebook page. Outline a thesis proposal. Conduct office hours. Grade projects. Go to a meeting. Come up with more advice. Answer user emails. Run a critique. Pretend

like everything is normal. Create even more advice . . . GFDA's accelerating momentum during that first month whipped our lives up into a whirlwind. Equal parts internet high-fives, celebrity nods, and hate mail were all blurred together with 300,000 unique visitors, millions of page views, and average times of well over two minutes spent on a text-based website we'd built for laughs.

The obvious next step was to somehow capitalize on the flood of requests we received for GFDA products before our fifteen minutes of fame were over. We had absolutely no investment capital, but we did have some spare time and a lot of friends to press for ideas (that's more or less a summary of our entire story, by the way, in case you'd like to save some effort). One such friend, Lawyer Jim, suggested that we hold a presale like recording artists sometimes do. We'd sell people *nothing* now on the speculation of receiving *something* later — what could go wrong? With what would soon prove to be abysmally insufficient forethought, we hopped into the cattle chute and strolled blissfully toward the slaughterhouse of entrepreneurship.

Soaring on the hubris that our prior success had set aloft, we calculated that we could build an e-commerce site in one night, and casually stopped for wings and beer before getting started at 9 p.m. We wasted most of the night doing everything except coding, like photoshopping hypothetical T-shirts and posters, writing copy, and conjuring up prices and shipping costs from guerrilla-style competitor analysis. Eight hours later, we had empty stomachs, throbbing heads, and a broken website. What we ended up with looked like a nonfunctional RedTube knock off (if you don't know what that is, don't look it up at work).

Although we didn't have much practical experience, technical knowledge, or, arguably, common sense, we did have Ricky, who mopped up our mess in a fraction of the time it took us to make it. And, twenty-four hours later, we also had a conjectural online store.

The presale launched with the promise that all orders would ship within a month's time (cue lightning flashing, dramatic organ music, and demonic cackling in the distance). We hired a friend of a friend to do the

Get fucking started.

printing on the stipulation that we'd sort out the quantities as we went. A few weeks later, we had around ten thousand dollars, five hundred or so combined orders for posters and shirts, and an as-yet-undiscovered festering catastrophe.

For the most part, screen printing is a fairly simple, straightforward process, and one presumes that any major impediments to success would make themselves apparent relatively early. That's very much incorrect, however, as we quickly learned when our printer informed us, in the third week of our four-week production window, that he was, for a variety of reasons, unable to start the job we'd assumed he had almost finished.

We had no product and no means of making any, and our troubles were only just beginning. As she does with so many fledgling commercial enterprises, Fate was preparing a shit sandwich for us that could have easily been mistaken as the work of a particularly ill-tempered Hellenic deity who's taken some mortal offense very personally . . . and is suffering from hemorrhoids . . . while going through a divorce.

Plan B was impromptu. Living in a college town, it was easy for us to find a vendor for the comparatively low number of shirt orders we had received. As for the posters, we instinctively tried to take advantage of the university's resources by skulking into the printmaking department to recruit some art student whose skill level and desperation for money might be a good match for our budget and deadline. One such victim who was unfortunate enough to take pity on us burned three failed screens before throwing in the towel.

Plan C was better aimed, if not better conceived. We went back to our shirt vendor and piteously begged him to burn a screen for us. He refused at first but, after dragging us around his shop for a few minutes as we clung to his ankles crying, he finally relented. He burned us two screens, one of which failed to set properly and fell apart on the car ride home. The second was held together by nothing more than optimism, but it did hold. Our problem still wasn't solved, unfortunately, since we needed posters and he only printed shirts.

Since plan D had the most time to develop, and was the best informed cumulatively, it was the superior plan. Having had our asses thoroughly kicked by this point, we came to the conclusion we were clearly not going to be able to finish this job on our own. Our friend Nate, a consummate hobbyist and a fine craftsman, happened to be dabbling in screen printing at the time, and was just good-natured enough to be unable to sense the imminent danger our presence in his life implied.

The printing began on Friday, precisely one week before our ship date, and ended on Sunday. None of us slept during this time. We spent three days ferrying fresh posters from Nate's basement printing station up a narrow flight of uncarpeted and unforgiving stairs to a makeshift drying room he'd prepared. It isn't possible to adequately describe the physical stress that we endured here, but endure we did. Having consumed enough energy drinks to give an average person permanent kidney damage, we managed to hand-print 400 three-color posters in just under seventy-two hours.

Measure Once, Cut Twice
Comforted in our false belief that we'd survived the worst of the ordeal and were now coasting toward the finish line, we headed to a print shop in downtown Cleveland to have our posters trimmed to size. Thanks to the 100 percent discount we'd generously been offered, this was the only professional service we could afford to employ, a fact that would prove to be a terrible irony when the gentleman operating the cutter, a full-time Baptist preacher and part-time pressman, made what he later assessed to be a barely noticeable error by cutting approximately half of the posters twice on the same side, ruining them. We were too exhausted and numbed by trauma to murder him. In a rare stroke of luck, Nate was also too morally grounded to murder us when we showed back up at his door for twelve more hours of printing. After another sleepless night and a full day of signing, rolling, folding, packing, and taping, we were ready to ship at last. The final gauntlet was the stone-faced line of baby boomers who made up the entirety of the understaffed Kent post office's patrons on the day after Thanksgiving. Though they certainly didn't seem to be an encouraging bunch under the best circumstances, today they would draw particularly deeply on their resentment for

Get fucking started.

millennials. As we groped and fumbled our way through the first of many long transactions at this soon-to-be very familiar Formica counter, we were assaulted from behind by a barrage of hard glares that could have set dry brush on fire. We wouldn't have been any more hated if we had invented rap music and canceled Wheel of Fortune while urinating in their breakfast cereal.

After the week we'd just had, however, the only way we would have let go of those contractor trash bags full of poster tubes is if they'd hacked off our arms with machetes. We made it. Everything shipped on time.

With that, we were officially in business.

Who,
m

Believe in your fucking self.

Why not? If *Everybody Loves Raymond* could run for nine seasons, anything is possible. Doubting yourself? Good. Doubt is proof that you gave a damn in the first place. Don't just doubt yourself; doubt everything. Doubt your limits. Doubt that you can't. Doubt that you'll fail. Turn doubt into belief.

**Think about
all the fucking
possibilities.**

(Attach a second sheet if necessary.)

Make the fucking

That thing you're thing that seems thing you're exactly what to have to do. it possible; makes it painful. the bold, so Whatever you're holding you back. endless reasons not make it, but to fail is being

leap.

avoiding, that
impossible, that
afraid of? That's
you're going
Starting makes
hesitating
Fortune favors
find your spirit.
holding on to is
Let go. There are
why you might
the only sure way
unwilling to try.

Get up fucking early.

A good day starts with good habits. Benjamin Franklin got up early, and now he's in a song by Puff Daddy. Be like Ben and be fucking disciplined. Discipline is cultivated from perseverance. If you can do it once, you can do it again, and then again. Wake up and accomplish something. Put on some goddamn pants and show a little dignity. Go work out, read, write, rap, sketch, or start something entirely new. And make your bed.

14	15
21	22
28	29

Start a new fucking project.

If you're waiting for an engraved invitation to get off your ass, it isn't coming. No more excuses. There's never going to be enough time, so stop wasting what you already have. You'll be dead before you're ready. If you wait until you've figured out what you're doing, someone else will have already done it.

Preparation over fucking planning.

Those who fail to plan might plan to fail, but those who fail to prepare should plan on having a lot of committee meetings. Plans can't account for the unexpected, and no one expects shit to go sideways (when it does, there's usually a fan in the way). Forget Post-it Notes and Sharpie markers; you better put wet wipes and ponchos on that supply list. Stop making plans and start making progress.

Get out of your own fucking way.

Strive for the best. Let go of perfection. Show up on time. Go at your own pace. Be prepared. Run with what you've got. Put in the effort. Take a break. Conserve your resources. Risk everything. Leave the past behind you. Don't anticipate the future. Think it through. Don't overanalyze it.

Know that you can do it. Accept that you might fail. Speak up. Remain silent. Hold your ground. Give in. Clear your mind. Dirty your hands. Be committed. Don't take it too seriously. There are enough assholes out there trying to hold you back; don't be one of them.

Don't wait to be fucking discovered.

You're not lost on the side of a mountain, or a new species, or the cure for cancer. There is no search party calling your name. No one is scaling the rainforest canopy to catch a glimpse of you. If you pop up in any lab results, you're more likely to be arrested than applauded. Get out there and start making your own discoveries (and keep a lawyer on retainer).

Set fucking goals.

Without focus, you'll squander your creativity. Without a destination, you'll end up where you started. Without a measure, you'll waste resources. Without purpose, you'll make meaningless work. You can't always accomplish your goals, but you won't hit anything if you don't fucking aim at something.

Aim fucking higher.

Get the future you want by giving up what you don't need right now. If you know more about graduating from wizarding school or who's in the playoffs than you do about your own skill level and competition, then you're to blame for your stalled progress. It's how you spend your time that reveals your priorities, not what you daydream about. You'll know you're serious about getting better when you're too afraid to fuck off.

Stop fucking around.

Stop whoring out your attention to online shopping and cat videos. All those distractions are going to impact your performance, and you're bound to end up with something leaking from your creativity. Do you really want to bring that home to your loving passion project? How will you explain this to your clients, for god's sake? That brief has been there for you since the start. Be faithful to your production schedule. Show a little self-control and keep it in your process.

Dreamin' ain't fucking doing.

Nothing goes better with a stiff drink at the end of the day than a wildly optimistic fantasy of the future. Doing it for real means getting your hands dirty. You're going to have to claw your way through every messy inch of failure. Put down the bottle and pick up some deodorant, because success is built on sweat equity.

Curation is not fucking creativity.

Other people's ideas make a poor placeholder for your own. Sharing articles you never read doesn't make you a thought leader, it makes you thoughtless. Your single-serving hero probably never even said that quote you just retweeted. How many pins does it take to get a feel for the art direction? Trick question: it's infinite. Step out from the background noise and create your own content, have your own opinion, and be your own fucking inspiration.

"　　"

...

— ?

DO THE FUCKING WORK

Change your fucking routine.

Stop running on autopilot. Routine is one step away from being in a rut. Just because it's always worked before doesn't mean it's serving you now. Nothing is a bigger threat to your creativity than the status quo. When Monday feels like Thursday, it's time to worry. Improve yourself by degrees, not by drastic measures. Getting a lot better starts with being slightly less worse.

Get in over your fucking head.

You'll never learn to swim as long as you can touch the bottom. Take off those water wings and doggy-paddle to the deep end. Better yet, go find a current to contend with because the struggle makes you stronger. Don't spend your career treading piss and cigarette butts in the shallow end of the pool; head out into the open ocean and fend off a few sharks.

Don't fucking censor yourself.

There's no room for politics in the grind. Do what's necessary, not what's popular. Give it everything you've got. Do your part to combat the diabetes epidemic and never sugarcoat the truth. Being offended is a choice. It's a cruel world out there; it doesn't make accommodations. Survival means making use of whatever you get, whether you like it or not.

Obstacles are fucking opportunities.

Most of our accomplishments have been demonstrations of tenacity, not talent. When we got lost, we learned to carve our own path. When the darkness closed in, we learned to kindle the light. When we couldn't see things clearly, we learned to look through the eyes of others. Every set of adverse conditions in the creation of GFDA led to a broader set of skills, a redoubled self-confidence, and a more bountiful, enjoyable life. The rewards for perseverance are always waiting just on the other side of what we think is impossible.

Police Academy
Graduate school changed our lives in ways that are as meaningful as they are indescribable. Having said that, the process also bore many unexpected and mostly useless gifts, such as a vocabulary enhanced by ineffectual academic terminology, a raw sensitivity toward anything left *unconsidered* in even the most pedestrian experiences, a framed piece of paper with an enormously disproportionate actual-cost-to-perceived-value ratio — the list goes on. For us, though, the one gift that managed to be simultaneously unexpected, meaningful, useful, and hilariously difficult to capture in words was the unique camaraderie that developed between our classmates. Without that community, everything would have been harder.

One night in the grad studio, at the conclusion of three days of exhausting, discordant work on our first major research project, a handful of us sat around trying to decompress (certainly not drinking because that would have been against the rules), when it occurred to Jason to leap onto one of the expensive Herman Miller chairs someone had optimistically entrusted us with, and ride it across the room like a surfboard. After a half-dozen or so passes the thrill had waned and he raised the prospect of transforming the chair from a surfboard into a waterski and riding it around the parking lot behind a car. A supply closet was raided for an extension cord, a suitable vehicle was selected, and any negative consequences went entirely untouched by forethought.

In a testament to its quality, the chair's casters lasted a solid twenty laps before one of them detached and skidded off into the grass. As we searched intensely in the dark, ineffectually parting dead leaves with our feet, we became engulfed in flickering blue lights. We instinctively attempted to appear as though we were standing in a parking lot in the middle of the night holding a chair beside an idling car with an electrical cord stretching from its open hatch purely by coincidence, but the evidence was glaring, even for the campus police, who'd boxed us in between patrol cars.

Two young, humorless officers stared down at us disapprovingly from their high parapets of authority, occasionally radioing HQ in low voices as not to feed us any intel on their next move. A certain excitement that tonight, finally, there was an offense serious enough to administer justice, yet minor enough to preclude laboring over legal technicalities, was held in check by a nervous alertness to potential threats. (It was dark, after all, and we were armed with a chair.) A litany of potential charges were recited: disorderly conduct, destruction of school property, reckless driving, vandalism, larceny, murder one. We explained ourselves as best as anyone could in such a ridiculous situation, but to no avail. The safety of the general public had to come first. The chair was collected as "evidence," and those of us directly involved were charged with misdemeanors.

After they left, we slinked back inside to salve our indignation by

reviewing the video footage, whose recording had gone unnoticed, thankfully, lest we'd also have been charged with conspiracy. As we marveled at the scale of our immaturity, we saw exactly where the wheel flew off. We retrieved it and called the officers, but they couldn't be bothered with the doubtlessly trivial effort of dropping the charges. They told us that they'd left the chair with the custodial staff (who'd called them in the first place), enflaming our resentment by revealing that we'd been charged for no good reason. The best we could do was absolve ourselves of any financial liability by repairing it, so we let the janitors yell at us in exchange for giving it back.

In addition to paying our fines to the city, we (grown-ass adults, every one of us) each had to write a two thousand word essay upon the orders of a bemused university judicial administrator, and prove via official, but covertly acquired, department correspondence that the chair had been returned.

What we got for our trouble, besides fresh humiliation with every new pre-employment background check, was a bond of trust that only comes from sticking together in the face of certain defeat. We and our classmates started grad school as perfect strangers, and ended up as partners in crime (literally).

Jason, Jason, Brian, and Jason

Our living situation in Kent would come to define this era of our lives in the best way possible, and the same can probably be said for all of our friends. As with everything else we did, the process of finding a home started as a source of constant pain and ended as a wellspring of treasured memories.

You already know who Brian and Jason are, so, just in case this isn't all confusing enough, we'll now take a moment to introduce another Jason (Richburg, who's coauthored this book) and another Jason (who hasn't). That's three Jasons and one Brian. Got it? Great!

The four of us were in grad school together and found ourselves in need of affordable housing. Carried along by a spirit of camaraderie born of necessity, we struck out to evaluate the prospects of moving into an ominously dilapidated but enticingly cheap house we'd found on

Craigslist. Having few other viable options, and lacking the time and energy to continue searching, we shrugged at each other in mutual surrender and signed the lease. The legend of the Windchimer began.

Rent-a-Wreck

The Windchimer (ingeniously named for the three sets of wind chimes some previous tenant had randomly left behind) was conveniently located at an equal distance from both the graduate studio and our favorite bar(s), so that one could walk to the former in the morning and stumble home from the latter in the evening, with a relatively low risk of being found dead in a snowbank after either trip. In that single aspect it was perfect. In nearly every other, however, it was pocked and hobbled by defects. While 1955 is surely a fine vintage for a ranch-style home in the Rust Belt, the Windchimer reflected a rather poor harvest. To write that the house was run-down is to rob the reader of the essence, the viscera, the theatrical quality of its state of neglect. Included in its list of subtle charms were: the grow lights in the basement; the verified blood stains on the unfinished wood floors; the fist holes gaping from every wall; the charred remnants of textbooks, beer cans, and nail-riddled trim in the fireplace; the thick, velvety tracts of black mold and the methodically smashed tiles in the bathroom; the lone piece of furniture, a cheap barstool upholstered with duct tape, featuring an upturned nail fixed in the center; the basement door labeled "VIP ROOM" in permanent marker; the stained sheet hung across exposed wall studs in that room; the massager and used condoms that fell out of that sheet. It was all those qualities, and the unrelenting filth of the place, that degraded the house from the relatively innocent condition of being a "mess" to that of an anthropological case study.

It's clear, in retrospect, that our suspicions should have been raised when our potential landlord, negotiating with us over the phone from an undisclosed location in California, warned us about selling drugs from the property, as he had taken certain precautions in the form of a spying neighbor. To preserve what little faith we had left in humanity, we decided not to lend too much imagination to what must have gone on before we arrived. Rather, we chose to look ahead, toward what could become of it with honest intentions and concerted effort. And, so, in an attempt to raise this broken structure to our standards of good taste, and any first world

Obstacles are fucking opportunities.

country's standards of basic sanitation, we agreed to refinish the house for a temporary (and unprofitable) reduction in rent.

In contrast to the massive obstacles we faced, we did at least have a few things going in our favor. We found a shaky rocking chair and a bucket in the garage, so, combined with the fireplace hearth and the now de-nailed stool, we officially had seating for four. Jason Bacher's dad, Big John, owned a nearby paint and wallpaper store, aptly named "John's Paint and Wallpaper," so we had access to all the technical knowledge and discounted supplies that we needed. Finally, professional creative types that we are, nothing invigorates us so intensely as a tight deadline and we only had four short weeks to finish the job.

Ranch Dressing

To most people, winter in Kent is a time of child conception, liver damage, and terrible driving conditions. To the roughly 24,000 university students, it meant going somewhere else for the holidays. To us, the newly minted Windchimers, it meant painting walls in an unheated house, each equipped with a pair of hobo gloves and a space heater to move between electrical outlets as he progressed. December in northeast Ohio can be rough. Negative temperatures and multiple feet of snow aren't uncommon. The winter of 2010, the year in which this work took place, was the worst in a decade. A usual workday unfolded as follows: We were shocked into a waking, shivering consciousness at around 7 a.m. Then we'd drag ourselves out of bed, wedge our extremities into the same paint-stiffened clothing we'd worn the day before, and stumble groggily into the fray. By 9 a.m., the sound of the first beer cracking open would lighten our spirits and set the pace for the morning. By 11 a.m., the third or fourth argument of the day would have erupted. By noon, all was forgotten over lunch. By 3 p.m., the level of alcohol in our stomachs would surpass our last meal and allow us to slip back into docile resignation to our bleak station in life. By 5 p.m., enough progress would generally have been made to justify another break for food. By 6 p.m., we'd weigh the possibility of giving up altogether, but retreat in the face of a legally binding lease agreement and get back to work. By 9 p.m., we would declare that we'd done enough, that it was too cold to continue, and that we should quit for the day. Then, after realizing that we had nowhere

comfortable to sit (discounting a barstool, a brick hearth, a bucket, and a half-broken rocking chair), we'd put in a few more numbing hours. At midnight, our bodies would demand rest. We'd lean our clothes back up in the corners of our rooms, take the plastic drop cloths off of our mattresses, and return to merciful sleep.

When we were finally finished, we'd graveled the driveway, patched and painted all the walls and ceilings, sealed all the floors, replaced all the missing trim, installed a bar-top in the wall between the kitchen and living room, de-molded the bathroom and replaced the fixtures, rehung most of the doors, repaired all the window screens, rebuilt the basement stairs, refurbished the kitchen cabinets, built shelving everywhere, deep-cleaned everything, and drywalled and carpeted a large room in the basement (where Brian had to live because he wasn't named Jason).

The process was primitive, organic, guttural. Our possessions were heaped in vaguely pyramidal mounds. Our often-improvised hand tools littered the floor and were worn from heavy use. We grunted in satisfaction as we squatted over greasy Mr. Hero subs and cold pizza, the short, high-caloric bursts that sustained us in our labors. Paint marked our clothing in crude, chalky stripes and plastered together the newspapers that were strewn about the floor in all directions like drying buckskins. Disemboweled Pabst Blue Ribbon cases showed evidence of frenzied ritualistic sacrifice, as their craggy shadows were twisted in the blaze of a shadeless table lamp being dragged across a cavernous room. To the narrow, fearful mind, this might all be a scene of degeneration, the loss of something necessary to get by in the modern world. A keener eye, however, would see a stage being raised in the dim, predawn light. Something was starting here, something was being born. The spirit of a thing was gathering itself up out of a primordial landscape; and we, its stewards, were totally unconscious of what was still to come.

Good Fucking Design Advice International Corporate Headquarters

Some weeks after we'd gotten settled into the house, without exposing any sort of plan, Jason Bacher built a small, counter-height table fixed to a wall in a poorly lit nook in the basement, his only explanation being that he needed a place to "do some work."

The physical incarnation of our business began with this single, legless plywood embryo, a molecular building block with the potential of unlimited configurations. Just as all living processes first trickle out unnoticed from hidden crevices and then gush past their banks to cascade across the landscape, GFDA escalated from germ to ecosystem in rapid order. The evolution of the workspace began with that pioneering table growing only a few innocuous barnacles: a tape gun, a stapler, a coffee cup bristling with markers. Then it mutated into a label station, and a new appendage extended outward in the form of a rolling cart for packing orders. Supply shelves were soon bearing surplus merchandise, flat files crept up from the shadows to consume the excess. Rarely observed fauna, like sticker machines and button makers, peeked through the foliage and added their clatter to the music of the lower jungle. Corkboard lichens raced across a twenty-foot wall, where printed ephemera, to-do lists, and obscene cartoons blossomed under the bright fluorescent light that now diffused through the newly rewired basement.

The original work bench was soon replaced by a more perfect descendant, one which reached confidently beyond the other stations. Adapted to higher functions, it was bigger and stronger than its predecessor. This new desk, a sixteen-foot monster coldly surveying its territory through two massive black retina displays, would become the central nervous system of the company. Many ideas would be born here, but few would survive unless proven fit for the harshness of life in the wild. Client projects, new advice, site redesigns, video conferences, team meetings, state-of-the-company addresses, employee-of-the-week award ceremonies, all-night sprints, wild-goose chases, moments of brilliance, tears of desperation, cheers of victory, beers of regret, and a great many things more: they all happened here.

In a matter of months, the basement of the Windchimer had been transformed from a dismal sex dungeon — fit only for such lowly inhabitants as laundry machines, hordes of spiders, and Brian — into a hybrid design studio/order-fulfillment center. Finally, with the bustle, laughter, and blaring music of the GFDA workforce (and a sprawling periphery of friends and students) lending it a vital spark, the whole affair lit up and sprang to life.

It takes fucking ~~talent~~ tenacity.

Obstacles are fucking opportunities.

The hill you're climbing right now is only one small point in a lifelong journey. There'll be many milestones to reach, many new plateaus to strive for. It's not where you're standing when you stop to look around that reveals the quality of the stuff you're made from, but the poise and pluck you demonstrate as you shoulder your burden and climb to the next highest place.

Explore all your fucking options.

Have you really considered what you're capable of, or just what you're comfortable with?

Listen to your fucking intuition.

Intuition gets clearer with experience. It starts out as a whisper that you'll strain to recognize. After a little seasoning and a lot of mistakes, it gets louder but more frenetic, and you'll have to filter out the bullshit. When you've finally earned the credentials to actually be asked for your fucking opinion, it'll tell you exactly what you need to say.

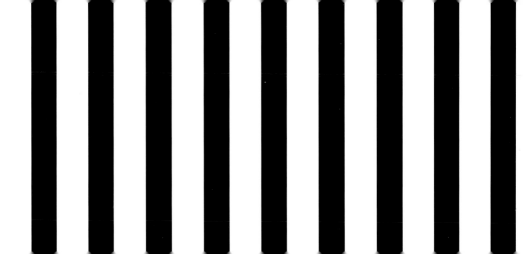

Solve problems through fucking action.

Don't get beaten for not fighting back. Even if you get your ass kicked, you won't be ashamed to tell the story if you get a few swings in. Most people survive ass kickings anyway, so you'll also get useful experience as a gift from the process. If you get back in the fight with some new resolve (and maybe just a bit of blind faith) to complement that experience, you won't keep getting your ass kicked for long.

A compu[ter]
Lite-Brite
fucking i[s]

...ter is a
for bad
...deas.

Neil's PowerPoint might be steaming garbage, but it's beautiful to him. Glossing the surface is the easy part; adding substance is what really matters. A diamond in the rough is exponentially more valuable than a polished turd. Seeing real value and being able to draw it out is the difference between being an expert and being an enthusiast.

Fucking start over. **Fucking start over.** **Fucking start over.**

Fucking start over. **Fucking start over.** **Fucking start over.**

Fucking start over. **Fucking start over.** **Fucking start over.**

Fucking start over. **Fucking start over.** **Fucking start over.**

Fucking start over. **Fucking start over.** **Fucking start over.**

Fucking start over. **Fucking start over.** **Fucking start over.**

Fucking start over. **Fucking start over.** **Fucking start over.**

Fucking start over. **Fucking start over.** **Fucking start over.**

Fucking start over. **Fucking start over.** **Fucking start over.**

Fucking start over. **Fucking start over.** **Fucking start over.**

Fucking start over. **Fucking start over.** **Fucking start over.**

Fucking start over. **Fucking start over.** **Fucking start over.**

Fucking start over. **Fucking start over.** **Fucking start over.**

Fucking start over.

Don't bother counting how many times you pick yourself back up: you only get credit for the last one.

Creativity is a fucking work ethic.

Creativity doesn't wear knit caps or polka-dot dresses. It doesn't have a $5,000 tattoo, a Ping-Pong table, or a waxed mustache. It isn't midcentury or postmodern, polished brass or reclaimed lumber. It's not irreverent T-shirts or inspirational quotes. It doesn't post surfboards, house plants, or cute selfies. There won't be an updated version or a new model. Creativity may be a lifestyle, but it isn't picturesque.

It drinks cheap whiskey and smokes unfiltered cigarettes. It has scars you shouldn't ask about. It's tough and gnarled, and old and pissed off. It ignores your opinion and it definitely doesn't give a damn about your feelings. Creativity kicks you in the ass when you get it wrong, and it kicks you in the ass when you get it right.

Use constraints to your fucking advantage. Sinking a shot isn't scoring unless someone's defending the goal. Crossing the finish line isn't winning the marathon if you're riding a moped.

Jumping into a swimming pool isn't really a magic trick unless you're wearing a straitjacket. The rules are a pain in the ass, but they're the line between glory and self-gratification.

DO THE FUCKING WORK

```
___  ___  ___    ___  ___  ___  ___  ___  ___  ___
 U    I    F      Q    S    P    C    M    F    N

___  ___  ___  ___  ___  ___  ___
 D    P    O    U    B    J    O    T

                   F    U    C    K    I    N    G
___  ___  ___    ___  ___  ___  ___  ___  ___  ___
 U    I    F      G    V    D    L    J    O    H

___  ___  ___  ___  ___  ___  ___  ___.
 T    P    M    V    U    J    P    O
```

Obstacles are fucking opportunities.

Key: The key is to not be so fucking lazy.

Chang
e
direc

There are two types of people in the world: those who know when to change course, and those who crash into a reef. This should include something about zagging when you're supposed to zig, but, let's be honest, most of us don't really know when to zig either. Having a solid plan and plotting a course aren't bad ideas, just don't be surprised when that nice, neat path from A to B ends up looking like an EKG.

Fucking ideate.*

~~Is it ideal to storyboard in the boardroom?~~

~~The nature of reality is transient and incorporeal, and one's perception of it will always be hopelessly skewed by the limitations of his individual perspective.~~

~~The iterative process is the cornerstone of creativity.~~

~~Knowing leads to delusion; not knowing leads to higher realization.~~

~~Don't forget to create a mind map when you drill down during your deep dive.~~

~~I'm sorry, but most of your ideas are terrible.~~

~~A robust solution is built on a system of analysis and editing, not conjured up in a stroke of genius. Even the best ideas have to be refined.~~

~~When sorting through possible solutions, it's very important to observe each stage of work objectively.~~

~~Should you go outside your wheelhouse to blue sky?~~

~~Prototyping is driven by a self-perpetuating system of experimentation, evaluation, analysis, and synthesis.~~

~~Maybe you need to sit and make a list while you onboard your brain dump.~~

~~The creative solution must be assessed with user-based research techniques, overlaying continuous versions, or iterations with clearly defined objectives.~~

~~Let's face it, most of us aren't fucking geniuses.~~

~~Analyze an iteration for its strengths and weaknesses, and then decide~~

Obstacles are fucking opportunities.

~~what to include or reject as you progress.~~

~~No truth can be absolute, nor any outcome made certain.~~

~~Understanding how the outcomes of an experiment are relevant to the stated project goals is critical for establishing limitations on the scope of the process and for sifting through less meaningful results.~~

~~Somewhere, underneath all those daddy issues and concepts for apps that nobody needs, deep at the bottom of that slurry of coffee and Pop-Tarts, there's got to be a good idea.~~

Be cautious of the bleeding edge whenever you decide to move the needle during your next bodystorm.

~~From the moment that the known is decided upon, one clings to a lifeless fragment of what's real; contrarily, in not knowing she allows vast and abundant potentialities to arise.~~

~~If there's a brainstorm coming with a chance of thought showers, then it's probably best to put on your thinking cap and prototype your spitballs inside.~~

Prototyping is especially beneficial when applied to solving experience-centric problems in interactive spaces with numerous dynamic elements.

~~If you have an unsuccessful iteration don't give up and start over; make something useful of it.~~

~~Two wrongs don't make a right, but a hundred and two wrongs might get close.~~

~~Always take constraints and opportunities to innovate into consideration when deciding what changes to make to a piece.~~

*You aren't going to nail it on the first try; you'll be lucky if you get it on the last try.

**Play to your
fucking strengths.**

Never **fucking** accept that your **fucking** differences are a **fucking** disadvantage. Why does the **fucking** square peg always have to be the **fucking** bad guy? Don't **fucking** take it for granted that there's merit to being stuck in a **fucking** hole. It's possible that you don't **fucking** fit in because you were never **fucking** meant to. Maybe you're a **fucking** cornerstone, or a **fucking** window, or some other **fucking** important square thing. Instead of doing what you're **fucking** good at, like holding everything together, or letting in the **fucking** light, you're too **fucking** caught up trying to be a stupid **fucking** peg.

Learn to fucking improvise.

When things go off the script and you have to make it all up on the spot, you're going to say, "Oh shit!" not, "Yes, and . . ." Learn the finer points of solving problems with bubble gum and coat hangers because when you get handed a prop it's more likely to be a ticking bomb than a funny hat. Improvising is more than making something out of nothing; it's winning the Daytona 500 when the odds have you at roadkill.

0:02

Be

fucking

patterns

patient.

Make your fucking uncomf...

Sorry princess, but it's going to take a lot more than slipping a pea under your mattress to get you out of your comfort zone. You have to get your head out of your ass and get your ass out of your chair if you want to get your work out of a predictable pattern.

ourself

ortable.

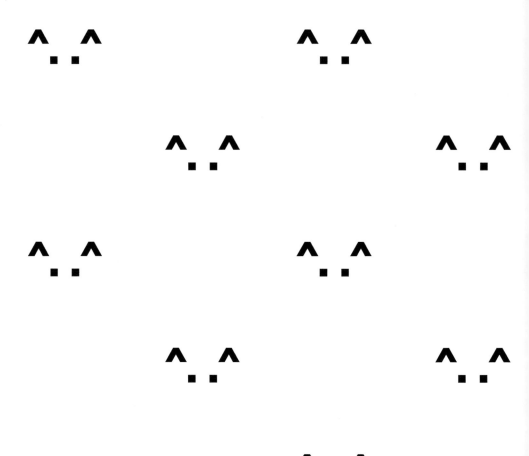

Defy fucking convention.

Be that guy in cargo shorts in the room full of furries. Following the herd might lower your chances of getting picked off but all the rewards will be picked over. Don't let your work blend in with the landscape; climb to the top of the canopy and claim some new territory.

Fail, fail, and fucking fail again.

We've never fooled ourselves into thinking that failing can be painless. It sucks, and it's always going to suck. The secret is not minding that it sucks. We've gotten our asses kicked every time we tried something new (and half the times we tried something familiar). After a few recoveries, however, we realized that a bruised ego isn't a fatal wound, and that success is more about allowing mistakes than knowing answers. Slowly but surely, we shed our fear, we got tougher, and we failed faster. Now we've proven that we can survive anything. Failure isn't comfortable, but it's reliable. Use it to your advantage.

Coffee Grinder

Six months after our first posters and shirts hit the streets, we expanded our line to include products that our discerning customers might find more practical in their daily lives. In one of mankind's less notable moments of innovation, we'd made it possible for someone to use profanity not only to express an opinion on such topics as procrastination and insomnia, but also to keep a beverage of choice piping hot. Unfortunately, our first coffee mugs came with a few constraints that had to be worked around. They only came in black and white, they were costly and time-consuming to produce, and they seemed to have an unadvertised self-destruct feature.

In adherence to the sage proverb which we've since appropriated as GFDA advice, everything we've ever made has been, at least initially, faked. We were no strangers to thin ice, but peddling coffee mugs brought on a lot of unforeseen problems. The mug game is a comparatively expensive one to play for anyone who's picky about quality and finish, which we very much are. We had to screen print the packaging ourselves at first because we could barely even afford to buy boxes. To compound the issue, every coffee mug on Earth is produced in China. Since we were inconveniently based in not-China, we had to place large orders to justify the freight costs and wait weeks for them to arrive. Mugs are cumulatively even more expensive to ship individually because they're heavy, so our profit margin was going to be relatively low even if everything went perfectly.

Most people, having already so narrowly escaped going out of business, and having tied up quite a bit of revenue in a new product, might pause and say to themselves, "Perhaps *this time* a plan is in order" or "Ceramics are fragile, let's reflect on that before shipping them around the world." Not us. The spirit of entrepreneurialism, which so often ill serves the well-intentioned but underprepared, combined with the heavy stresses inherent with surviving graduate school, set us up for inevitable, yet totally avoidable, disaster.

Just a few days after procuring, advertising, and shipping mugs, the angry emails started. And these weren't the funny kind of angry emails from people who don't like the f-word. These were justifiably angry emails from people with broken coffee mugs. A lot of broken coffee mugs. A majority. We soon realized that we were going to lose money on this launch if we didn't find a solution. Naturally, our first inclination was to blame someone else. Had disrupting the predictable and cathartic workload of the post office employees driven them to retaliate on us mafioso-style by smashing all our boxes? Was our supplier laughing with impunity from across the Pacific at our gullibility in accepting their defective merchandise? Was this some sort of conspiracy by the religious far-right? Natural disaster? Supernatural intervention?

Nope, we just fucked up.

Randomly, on one of our more bedraggled but now daily trips to the post office, upon overhearing our lamentations, a postal worker, with devastating matter-of-factness, chimed, "Coffee cups? Oh yeah, ya gotta double-box anything fragile." As we drove home, we smoldered in silent disgust at the fact that this woman had waited until our defeat had ripened on the vine before sharing her professional insight (despite the hundreds of times we'd declared the contents of the clearly single-layered boxes we'd put directly in her hands). In the end, though, underneath the sort of arrogance that's particular to designers of all sorts, we knew we'd lost because of our own ignorance. Not once did we look into this torturously obvious aspect of the process. Our failure happened at the beginning of this venture, not the end.

Developing Friendships
Remember the early 2010s? The iPhone 4 had just hit the streets and it seemed like the prospect of staring at a screen all day was going to be more George Jetson than George Orwell. In the minds of creatives and clients alike, there was one, and only one, possible end solution to any advertising, branding, or communication problem: build a mobile application (typically divined without the inconvenience of even token market research). This phenomenon stood in stark defiance to the fact that, to the average designer, high-end app development might as well have been an arcane sorcery practiced by only a select few cloaked initiates with fantastic powers. How one was to acquire this miraculous cure-all for whatever commercially ailed him was not often clear; we all just knew that obtaining it was the true path to commercial success.

Though GFDA was usually too busy stamping out real fires to get distracted by hypothetical golden geese, our eyes glazed over with the same viscous sheen as anyone else's whenever a late-night jam session would inevitably breed the phrase "we need an app." So when a young computer science student from Arizona State University contacted us out of the blue to share a prototype that he'd been working on in his spare time, it was auspicious, to say the least.

We instantly liked Tim. Sure, he was bright, energetic, and polite, but more important, he was real smart about computer things and the only compensation he asked for was attribution. Correction: we loved Tim. We insisted on flying him out to our international headquarters, putting him up in the presidential suite at the Windchimer (i.e., the good couch) and lavishing him with all the pizza and beer that our corporate spending account would allow.

The next several days were spent "collaborating" on the completion of the app, with us doing the heavy lifting of scrutinizing whether a few pixels might be shifted left or right, and identifying the correct hex value for GFDA red. Tim mostly just tidied up odds and ends, like writing all of the code and doing functionality testing. Since he played such a diminished supportive role in the development process, we wanted to make sure he felt like he was earning his keep, so we also put him to work rolling posters and packing orders.

Despite all our hard work, and even Tim's few noteworthy contributions, the App Store rejected the app three times in six weeks. Though we were impressed with their turnover, the results left us all feeling totally deflated. The reasons were shrouded in mystery, but two pivotal factors took form in the fog. First, Apple was very protective of its brand experience, and, since literally every page of our app contained profanity and, in fact, the only purpose of the app was to deliver profanity, we never really stood a chance. Second, it was basically just a downloadable version of our website and didn't offer the user any unique functionality or service. That's the ultimate lesson from this story. Our mobile app failed because, like 99.9 percent of all businesses, we didn't need an app.

Show Business

Selling things is good, so selling a lot of things at once must be better. Never being ones to contradict sound logic, we're constantly seeking ways to increase our wholesale orders. After we failed to accomplish that through cold calls and blind luck, it came as a welcome surprise when the New York Stationery Show reached out to us in the spring of 2017 and invited us to attend. The catch was that we only had two days to make our decision, as well as come up with the sizable deposit

Fail, fail, and fucking fail again.

to reserve a booth. Following our usual formula for success (which also happens to be our formula for failure), we shot from the hip and sent in our check.

As we began making plans for our space, we quickly learned of a second catch. Should one want the luxury of booth walls, there were only three options: 1. Have some sort of commercially manufactured, modular setup that met the show's stringent regulations. 2. Buy the expensive, uncommon materials necessary to make one's own walls that met the show's stringent regulations. 3. Pay a ridiculous additional fee to have walls installed for you. For the mere trifle of a few thousand dollars, an *approved contractor* (Teamsters) would build our *walls* (sheets of foamcore haphazardly zip-tied to rails) and install *utilities* (a four-plug power strip) that didn't include lighting. This was all a racket, of course, but, having very little time and no desire to be dragged down to the docks and beaten with lead pipes, we paid our dues.

Our set-up budget was already in a steep deficit, so we keenly settled on a minimalistic booth design with lots of negative space. We had our trademark and slogan – "Colorful, well-designed merchandise for people who give a fuck." – cut from vinyl, purchased a few cheap clamp-on lights as an amenity for our visitors, and built product displays. We planned to debut the swear jar (a glass jug that allows our customers to profit from their potty mouths by collecting their change) at the show, and, out of a sense of propriety, a handful of greeting cards. We included samples of our posters and mugs and a stack of pulp wholesale catalogs, strapped it all to a handcart, and descended into the New York subway system where we were sure to make lots of new friends on our way to Manhattan.

There were a variety of distinguishable types among booth operators, but, generally speaking, all of us could be divided into two castes. There were the pros, the perpetual star quarterbacks and homecoming queens of the world, and the amateurs, pimple-faced band nerds randomly trolling for prom dates. It should come as no surprise that we were unmistakably in the second group, which made our odds of success at winning sales by putting on a brave smile and awkwardly greeting every disinterested passerby that much lower. It took only a loose command of

the obvious to realize that there was a vast cultural misalignment between GFDA and the New York Stationery Show.

Our "colorful, well-designed merchandise" did at least turn a few more heads than the conventional cards most of our fellow rookies were piteously offering up to cruel fate. Even with that advantage, it was apparent that whatever anemic business was likely to come from the droves of polite window-shoppers wasn't worth the excruciating blow to our dignity.

By Tuesday we said, "Fuck it," and started wandering around the show drinking the bottle of medicinal bourbon we brought to treat snake bites. So many companies were using the same inky script typeface, the sort you'd default to while setting "live, laugh, love" on bridesmaids' gifts at gunpoint, that we started taking shots every time we saw it. That only lasted about ten minutes, as it became clear that we'd finish our walking tour in a wheelbarrow if we continued, but the thoughtless conformity oozing from most of our competitors sparked something brilliant in Brian's now well-lubricated brain, and we rushed back to the booth.

Producing a small sandwich board and some chalk from god knows where, he wrote "Today Only! Self-guided booth tours, ~~$5~~ FREE!" and proceeded to draw arrows on the floor (à la IKEA showroom) following the perimeter of our eight-by-ten-foot booth, leading to each section of our products accompanied by a line of smarmy commentary. This was presented with a new schtick that was half carnival barker, half Lucy Ricardo, and half drunk. It was a hit. People commented that we had the best booth in the show, and buyers who had been coming for years told us that no one had ever even attempted to break the mold before.

Sadly, it was too little too late. By the end of the last day, we'd only earned eight hundred dollars in sales, and could count on maybe another five hundred or so annually in return business. At the current rate, it will still take us about seven more years to recoup our losses (not counting for inflation).

Therein lay our failure. Those people wanted, and needed, the irreverent spirit of GFDA, and, rather than having the confidence to be ourselves, we gave them the sort of effort to fit in usually reserved for accepting one's first cigarette behind the dumpsters in ninth grade. Would the outcome have been any different if we had had the foresight to make Brian's smart-ass idea our conceptual direction from the start? We'll never know for sure, but we definitely would have taken more pleasure in the experience, and found at least a small level of success in our failure.

Keep your fucking chin up.

Keep your lips sealed, your nose to the grindstone, your ear to the ground, and your eyes on the prize. When you're weak in the knees, don't shoot yourself in the foot — dig in your heels. If you're up to your neck, just let down your hair and open your mind. Don't stick out like a sore thumb if things get out of hand; grease some palms and cross your fingers. You'll only deserve a pat on the back if your heart's in the right place and you work your ass off.

Admit when your fucking wrong.

Fail, fail, and fucking fail again.

Remember that time when you were so absolutely certain that the FJÄLLBO coffee table wasn't going to match your couch that you refused to back down even after your significant other started crying in IKEA? Well, you were wrong. Brace yourself—you're wrong a lot. In fact, sometimes saying "I'm wrong" is the only time you're right. It might even be wise to start there on occasion.

Lose your fucking ego.

Just like that STD that you may or may not have gotten in college, if you don't deal with your ego it'll keep popping back up and your relationships will suffer. Subscribing to YouTube life coaches and wallpapering your Instagram with self-help books is like using that topical cream you bought in disguise on the other side of town: it only hides the symptoms. You're still going to have flare-ups. Don't be insecure and run from your vulnerabilities: look at the issue with honesty and humility.

FUN
IN
PA
YO
SE

C	K
G	
C	E
U	R
L	F

There is no fucking right answer.

The best is the enemy of good enough. Perfection is an ideal, not a goal. Time spent arguing, daydreaming, and hunting unobtainium is time wasted. Focus on what can be done now instead of what might never happen.

Brea k

fuc
r

Forget about your reputation. Ignore the warnings. Go off looking for trouble. Leave your toothbrush at home. Rip the allergy information right off that pillow and throw it in the wrong recycling bin. Don't stop pushing the boundaries until you're running on bare rims and there are sirens approaching in the distance.

the king ules.

Don't make fucking excuses.
Make something of your flaws instead of making excuses for them. Can't show up on time? There's a rough spot on the surface of your better self. Polish there. Don't have the technical skill to do the work? Polish there. Hate your fucking job? Polish there. Being respected by others starts with being honest with yourself.

Don't make fucking excuses. Make something of your flaws instead of making excuses for them. Can't show up on time? There's a rough spot on the surface of your better self. Polish there. Don't have the technical skill to do the work? Polish there. Hate your fucking job? Polish there. Being respected by others starts with being honest with yourself.

Fake it until you fucking make it.

Don't let go of your aspirations just because you lack resources. If you don't have a Gucci, practice using that glue gun. If you don't have a BMW, put some racing stripes on that Hyundai. If you don't have a degree, google your way from ignorance to amateurism. If you're the only one who knows the difference, there's no difference. Walk into that first meeting like you invented that shit, even if you're not sure exactly what it is.

I ♥ clichés

Don't succumb to fucking clichés.

A strong concept is crafted, considered, scrutinized over; it doesn't materialize out of thin air fully developed. If a lightbulb suddenly appears over your head, the idea that spawned it probably isn't very original. Keep trying.

Be fucking persistent
persistent
persist
persi
per
pe

Success is 99 percent resuscitation. You haven't failed until you've given up, so just don't give up. Feeling exhausted? When you're really exhausted you'll drop dead. What motivated you to get started? What's changed? If there was a reason to get in, there's a reason to stay in.

persistent.

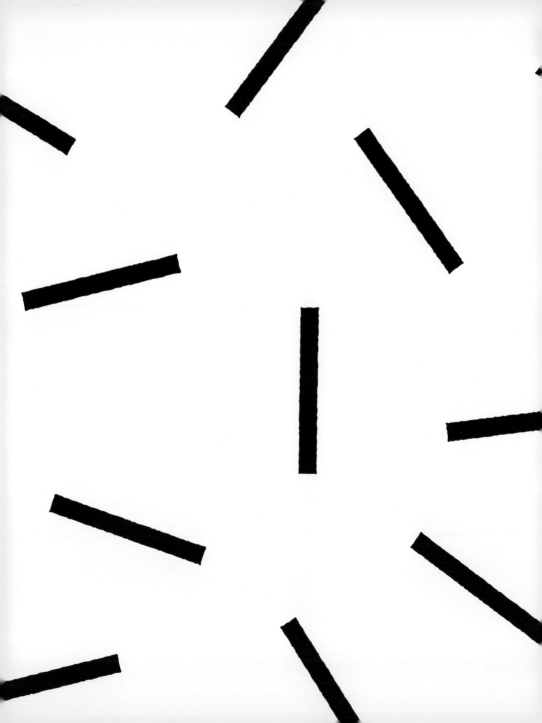

Celebrate your fucking failures.

Hooray, you suck! You won't get a trophy for that, but you will get some experience (unless you're dumb). Don't barricade your fragile ego behind accolades, status symbols, and mounting proliferation; just accept that you're going to lose sometimes. Lean into it. Use it as feedback. Every failure brings you one step closer to success.

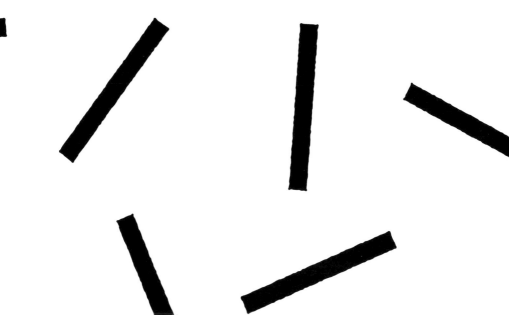

Don't sweat the fucking small stuff.

It's

all small stuff.

Learn from your fucking mistakes.

Maybe there's a part of you, deep down inside, that finds security in fucking up. Maybe if you got your shit together, you'd have to keep it

together. And maybe you don't know if you can do that. Maybe if you did, though, you'd realize that keeping your shit together is what keeps your shit together, and it's only hard because you make it hard. Pay attention to your mistakes, listen to what they're telling you about yourself.

Mistakes make us fucking work.

Mistakes make great fucking work.

Do your job like a five-year-old draws a house. You don't have to labor over clean lines and structural integrity if your priority is making sure the sun is shining and the cat is smiling. Sometimes making a mess of things is evidence that you're getting past your control issues. Sometimes it allows magic to happen. It's okay to have a squiggly head if it means you have an open heart.

Measure twice; cut fucking once.

Your granddad made it look deceptively easy to build sweet bookshelves. Creating something that can stand the test of time requires accountability for your actions, not activity on your social media accounts. Tapping squares on a phone doesn't demand much presence of mind, and the results don't add up to much over the years. With a band saw you know you've made a lasting change when your thumb flies across the room.

Measu
cut fu

Your granddad made
bookshelves. Creatin
requires accountabil
media accounts. Tap
presence of mind, an
years. With a band sa
your thumb flies acrc

Practice practice makes fucking

Perfect. fucking takes perfect.

Perfection is impossible, but don't let that stop you from trying. The point isn't to get so good that you stop making mistakes, it's to get so lost in your work that you stop thinking about them. Your talents are in you, just waiting for you to let go and get out of the way. That's what takes practice. That's purpose. That's worthy of a lifetime. Perfection is a good goal precisely because it can never be reached.

You won't know until you fucking try.

You don't know. You don't fucking know. Maybe you can . . . maybe you can't. You might. You should. Will you? Why not? That's bullshit. You don't know. But, if you try, then you'll know. Then you'll see into the darkness and know. Then danger will take a surmountable form, and reward will lay in a reachable place. Then you'll know what to do when you try *again***. Only courage can contend with the unknown. Fear and desire just contribute to it.**

CAN **CAN'T**

Ask for fucking help.

Forming partnerships always makes our work better because the end result is always unpredictable – something more than we were capable of envisioning on our own. Valuing collaboration over control means accepting that things are going to get a little messy sometimes. Being closed off can't protect you from the chaos of the world. Your own mess is still going to be there, even behind the best defenses. Isolation can only deprive you of the help you need to face the unknown. Creativity demands openness and hates barriers, and we've learned that self-imposed barriers are the most obstructive. Let in the chaos of collaboration. Give others the freedom to be themselves. Allow something unexpected to happen.

Internment

When the dust finally settled on our odds-defying, Hail Mary approach to starting the business, we realized that we were at a turning point. We had a choice between walking away from our fifteen minutes of fame relatively unscathed but with nothing to show for ourselves or seeking our fortunes by relaunching our website and building an operational model for fulfilling orders.

Naturally, we followed the path of most resistance and chose to stay in the swear-word game, but we knew that our educations, families,

friends, students, and sanity all needed their respective pieces of our time. In a rare move toward self-preservation, we accepted the fact that we had to seek help. We recruited another Brian to handle the web development (for those keeping count, we're at two Brians and three Jasons), but we still had more demeaning grunt work than we could reasonably do on our own. What we needed was an intern.

Eric was a handsome, talented design student and musician. So we decided to give him a chance to tame his ego by being our first intern, and ultimately accomplished precisely the opposite effect. There's probably some fine print in the internship paperwork where we agreed in writing that his work would be contained to design and marketing, but, ever defiant of institutional regulation, we had him cycle through every role in our company. It proved to be a wise move on at least one occasion when our original poster printer, Nate, was using a scrap of black paper to clear a screen loaded with black ink, and Eric, acting as the official printing gofer for the day, saved it from the trash and christened it "Murdered Out" (like a rapper's all-black Bentley). Thus the ever-popular black-on-black classic advice poster was born.

Since our first intern had provided the kind of youthful exuberance that kicks over a secondhand 10-watt Marshall amp after a screeching guitar riff in a one-car garage, we felt that we needed a bit of grounding in our next choice. Mari, also known as "Meatball," had inherited from her Italian ancestors the same work ethic and attention to detail that built Hadrian's Wall and Saint Peter's Basilica. Meatball could finish a job before we could finish a sentence. She was exhausting to keep up with. We finally admitted defeat and gave her real problems to solve, like honing the user-based aspects of our services. Within weeks, she was elbowing us out of her way to spearhead the massive transition between shipping platforms that our growth and site redesign had made necessary.

We wouldn't take on another intern until a few years later, when Jason needed an assistant in New York. One applicant's email, in particular, had just the right mix of length and discomforting tone of familiarity to stand out as the product of a dangerous mind. To her credit, what Katherine lacked in brevity she made up for in intellect. Even during an impromptu

interview in Jason's Brooklyn apartment, she unflinchingly volleyed every grilling question Jason threw at her while his dog, Rooney, chewed on her hand (earning her the moniker "Milkbone"). She proved to be brilliant at more or less everything, and her work took a high-arcing trajectory over every aspect of the business and brand. Her wit was also a fine addition to our culture, as demonstrated by her habit of communicating with Brian exclusively through haiku:

Poem to reply to plea for permissions:

Google Drive email
currently in your inbox
contains the shared link

—

Poem to deliver more information:

The Basecamp project
has all the information
to initiate

—

Shoplifting

Our product line had grown considerably in the three years since the original Classic Advice Print. Orders were now flowing in, and GFDA was running like a well-oiled cussing machine. Additionally, we'd begun getting paid for talking, and talk is cheap, so business was good. Good enough, in fact, that, even with the help of interns, our bandwidth was stretched to its limits. This growth marked two critical milestones: we now understood our daily operations backward and forward, and we had somehow squirmed just past the poverty line and into the salary range of fast-food management. We were finally in a position to hire actual employees.

Rachel was a newly recruited master's candidate in the design program who still had that twinkle of life in her eyes which revealed that her

humanity hadn't yet been supplanted by the apathetic and embittered golem of the academy. We had to act fast to save her soul. Deep thoughts sprang from Rachel's fertile mind, and she eventually became our wholesale processing expert. Also, acting as chief executive garden gnome, Rachel exercised the full power of her office by starting an organic vegetable garden without bothering to ask anyone for permission. (Like, a really big one. In our front yard.) Though everyone involved with GFDA was full of shit on some level, she was the only person who brought actual bags of it with her to work.

Molly, another fellow grad student, was the order-fulfillment capo — a position that allowed her to stand in a corner facing a wall with her headphones in and remain in silence for hours at a time. It may have been the happiest period of her life . . . or not, we aren't really sure, since she never spoke once in the year that she worked with us. Molly was also a yoga practitioner and a free spirit, so when we often found her on the couch cocooned in a wool blanket, exposing only her nose through a small breathing hole, it wasn't clear to us whether she was seeking ascetic detachment from the material world or just avoiding conversation.

Logan snuck into our employment under the guise of being a typical college student, but, in reality, he was a 1950s-era paperboy. You just wanted to ruffle the kid's hair and take him out back to toss around the ol' pigskin. After polishing off a tall glass of milk with a few enthusiastic "golly"s and "gee whiz"es, he'd take the baseball bat and catcher's mitt off his shoulder and get to work. Because of his obvious gift for visual design and a very sharp eye, we ended up relying more heavily on Logan's contributions to our client projects than our store. We must not have been the only ones impressed with his ability because he's now a big-shot designer in Manhattan.

Friends with Benefits
Our house was a sweatshop by default because it wasn't air-conditioned. We embraced that identity and abandoned such proletariat nonsense as union regulations and OSHA safety standards. A GFDA work shift could last upward of twenty hours depending on who fell asleep watching TV. The dress code was kept vague to allow rent-paying tenants the sort of

freedom with their bodies that nature intended. Our only concerns with tossing sharp objects across the room were judging the throw for style and distance. The basement stairs were kept dimly lit for the sake of ambiance, which didn't really matter since fire egress was virtually impossible. In contrast, staff enjoyed such perks as on-the-clock dance parties, all the Netflix they could watch, access to a full kitchen that someone else would inevitably clean, one unisex bathroom, unlimited laundry service, ample parking in the front yard (in stark violation of municipal law), homemade sushi dinners, enough free cardboard boxes to bounce between shitty college housing into perpetuity, and, last but not least, a spacious employee break room featuring two couches and a kegerator.

There are some distinct inconveniences that come along with allowing your business and your home to homogenize into a giant life slurry (timely access to that single bathroom being an excellent example). Outweighing any negatives by magnitudes is the family that unexpectedly grew together from so many randomly gathered, misfitting pieces. Because of GFDA, our home became everyone's home. We ourselves had no inclination to take responsibility for other living things, yet we had a garden growing upward by inches and outward by bucket-widths. The same household distractions that we had to escape in order to write our theses provided the perfect background noise for others to write theirs. People who had spent the past five hours together frantically trying to complete orders before the post office closed lingered over good Chinese food and bad movies for the rest of the evening. There were friendsgivings, moving parties, pointless arguments, and drunken midnight confessions of fears and dreams. Lost loves were washed away with tears, and fresh starts were buoyed with laughter (so much laughter).

Paychecks could never adequately compensate these people for what they gave to us. They helped us in ways that we never knew we needed and will probably never be able to fully express.

HAVE FUCKI HuMIL

SOME
NG
NG
ITY.

Aa

Get a fucking mentor.

Good teachers have a fire inside them so big that it's bound to light you up. Good teachers want their students to surpass them. Good teachers tear down their old ideas so you can build new ones of your own.

Ask good fucking questions.

Never suppress your desire to learn. It's better to look stupid than be ignorant. Anyone who doesn't have the patience for your questions is insecure about their own struggle to progress. But no matter how much help you get, the most useful questions are the ones that you ask yourself. The right questions take years to answer, or confirm that there is no answer. Nothing can be known completely, but nothing can be left completely unknown.

professional
proficient
patient
present
persistent
particular
prevalent
prompt
prepared
poignant
profound
polite
purposeful
passionate
practical
provocative
peaceable
poised
productive
perceptive
persuasive
pioneering
pliable
potent

Ask for fucking help.

Be your fucking self.

But don't try to be perfect. You're not.

If your idea is dumb and you succeed anyway,

If your idea is dumb, someone will tell you.

Share your fucking ideas.

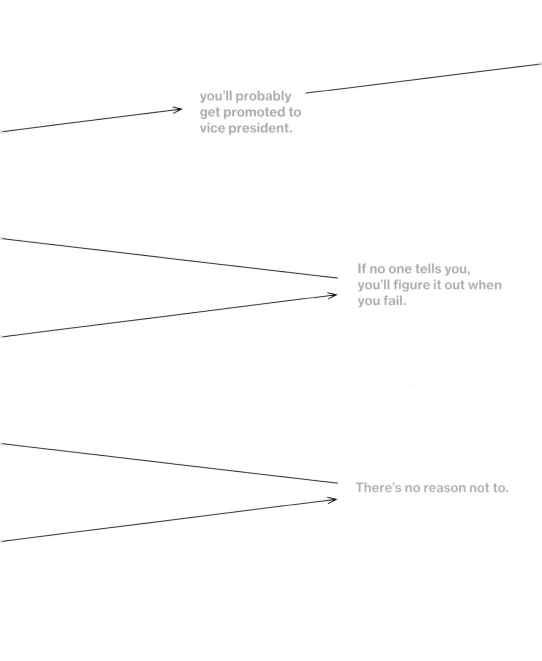

Be fucking flexible.

Stretch it out. Limber up. Take a few minutes to warm those muscles. The things you'll have to do to get ahead in this world are going to require a lot more flexibility than Downward-Facing Dog. You're going to get pulled in directions that you didn't even know existed. Don't let fear make you rigid. *Be willing* to extend yourself beyond what feels comfortable. You don't *have to* be able to put your ankles behind your head; you just have to *bend to* the circumstances.

Ask for fucking help.

Don't reinvent the fucking wheel.

If only there were some means of moving things across long distances without dragging them on the ground. Now that the problem has been defined, it's time to start prototyping. While you're at it, work out a few concepts for a device that lets you lift small portions of food into your mouth. Maybe you could also put together a committee to finally sort out a viable plan for what to do when it starts raining while you're standing outside. Check around first, though, just in case someone else has ideas you can borrow from.

Ask for fucking feedback.

Asking for feedback is like asking for a colonoscopy. There are some things you'd just rather not put on display, but you can't afford to ignore them. It's better to be thorough than agreeable, so find someone with a lot of experience and a sharp eye, not warm hands and a gentle smile. You'll probably make a few unpleasant discoveries, and after it's over you may need to make some changes, but a slow death is worse than a little probing in the end.

Learn to take some fucking criticism.

If you want to be good at something, you have to be humble enough to learn what you're doing wrong. Smoothing out the rough spots is irritating and uncomfortable, and, worse, you can't do it on your own. Prepare yourself to be scrutinized; no amount of high fives will lead to improvement.

Collaborate with your fucking

When you're supposed to be setting the explosives, don't randomly decide to take a few seconds off of the timer without running it by someone else. Everyone has their own job to do, but everyone's job is to accomplish the mission. Strap that C-4 to the bridge, trust the machine-gun guy to clear the path for your escape, and blow those success metrics to pieces.

Keep good fucking company.

Some people teach you through what they accomplish, and other people teach you through what they avoid. Surround yourself with high achievers in all arenas. Throw a few rogues and miscreants in with those trendsetters and captains of industry, and find something useful in all of them.

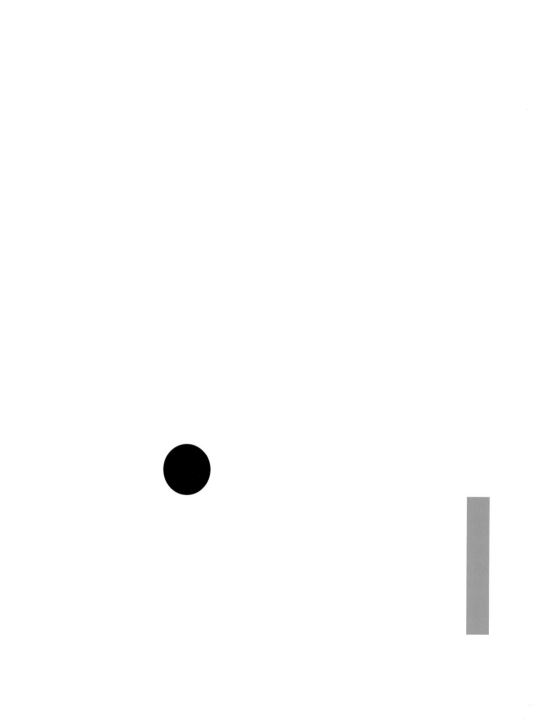

Erbamce fckunig cohas.

Choas is the bgeninnig. Choas si potnetail. Cahos hodls the pwoer of the uwknnon. Craetviity and callobraotoin are chtaoic bcuseae teh'yre unpedricabtle. That's tiehr vlaue. Yuor sklil and porfsesoniaislm are waht bnirg them into order. Measure your partnership by its products, not the procedure.

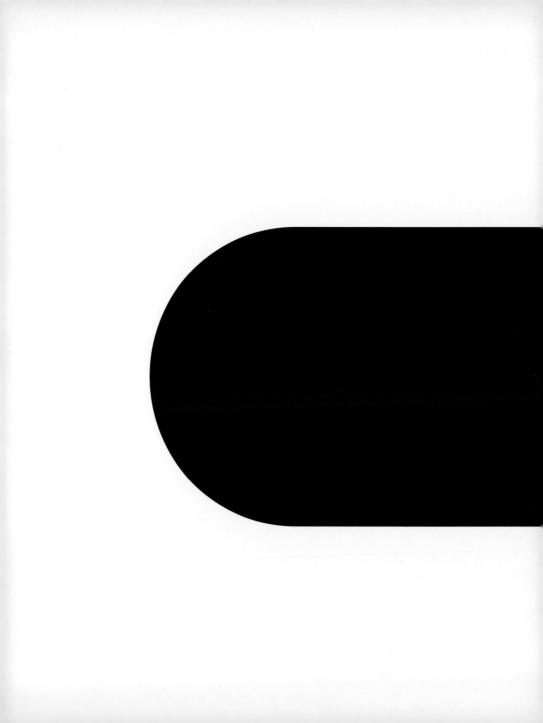

Get over your fucking self.

Whether you think you're a misunderstood genius or the root of everyone's problems, you're wrong (probably). You're just as messy, just as full of potential, as the rest of us, but it's your responsibility to sort yourself out. It's a tough pill to swallow, and no one is going to hide your heartworm medicine in a chunk of hot dog. Face your issues, then let them go.

Learn to fucking listen.

Those who say don't know, and those who know don't say. If you find someone who is both knowing and saying, just shut up and pay attention.

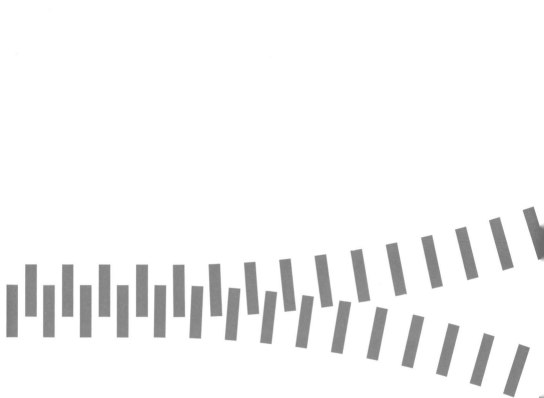

Give up fucking

Somewhere in the past there's a cigarette butt, empty bottle, half-eaten cheesecake, discarded treadmill, or broken heart that proves you can't always control yourself. So don't try to control anyone else. Let go. Give in. Cut loose. Back off. Cede. Relinquish. Yield. Release. If you hold on too tightly, you might just squeeze the life out of your partnerships.

control

Show some fucking passion.

Preparation, expenditure, shoring up, and battening down can, at their highest effect and maximum return (with no slight reliance on luck) only put the conditions in place for the actual living experience to happen. The rest is a matter of diving in headfirst. GFDA has always been setting a higher bar, running a longer sprint, making a farther reach. We're always trying to find the end of our strength, always trying to fail as genuinely as we're trying to succeed. This is how living a true, tactile, palpable, painful, burning life should feel. Just like creativity, life isn't a thing to be grasped and held on to. It's a thing to be swept away in, without control or certainty. In some strange alchemy that could never be revealed in words, the flames of passion don't consume but purify. It's not what we get out of pursuing our passions that matters, but what we are able to let go of.

House Fire

It isn't the love for our jobs that's made life enjoyable, but the enjoyment of life that's made our jobs lovable. We've worked as hard off the clock as on, and every bit of the energy, irreverence, and attention to detail that's gone into our business has also gone into enjoying our time at home and with friends.

By 2012 we'd lost one Jason, and gained an Eric and a Todd. It's difficult to say if it was a fair deal, but the rent got paid in any case. This change in personnel led to a potential threat to our painstakingly cultivated way of life – Eric and Todd were both just rising from their undergraduate experiences, after all, and lacked a certain refined patina. To ease our worries, we developed a series of protocols and compiled them into a handbook for new inductees to the Windchimer. This venerable document addressed issues ranging from parking etiquette to personal appearance, and thereby helped its owner avoid any embarrassing faux pas. With our house in order, we bought our own bullshit wholesale and officially began calling ourselves "Windchimers." We even printed honorary Windchimer membership cards and issued them to anyone who met our stringent standards (i.e., anyone).

Between the daily foot traffic of GFDA associates, ~~drunken debauches~~ collaborations with our fellow grad students, motley troops of acquaintances, and the miscellany of design school dregs that got collected in our sieve of general misrule, the Windchimer was a frothy melting pot of local society, and an institution unto itself.

Every year we hosted two large parties to coincide with the end of the fall and spring semesters. The holiday party included door prizes handed out as wrapped presents (usually charcoal briquets or broken GFDA coffee mugs because all our friends were on the naughty list). The spring gathering was the official after-party for the VCD Senior Show, the capstone of completing the design program, where some students receive merit awards. We presented our own awards to certain seniors for such monumental accomplishments as "coming to the party." Every Windchimer party was promoted on campus with posters, and we gave out hand-printed coasters. There were always inappropriately detailed but incredibly popular house tours that towed rotating groups of fifteen or twenty people from room to room. One of our greatest sources of pride during those years was that, out of the hundreds of guests who showed up to our parties, design students, faculty, and staff all felt comfortable together in our home.

Of course, we put just as much effort into entertaining ourselves as entertaining our guests. Jason Bacher, who's always incubating some

Show some fucking passion.

maniacal scheme, once got dangerously serious about turning the house into the world's largest ball pit — so serious, in fact, that standing records were consulted and sample balls were ordered. Much to the preservation of everyone's ability to get to the bathroom in a timely manner, and his own ability to avoid being strangled, he backed away from the ledge. One Christmas, Brian decided that we couldn't call ourselves festive unless we took family photos. We put on our Sunday best and strolled into our local Walmart. It wasn't clear whether the attendant's soul had been completely depleted by her job, or unrelated grown men in Christmas sweaters are just a large part of the customer base, but she didn't bat an eye at us. After a series of pose and backdrop combinations that can only be described as shameful, we mired the assistant manager in an intense, psychologically draining, multipronged haggling offensive that clearly had not been covered in her online training courses. We walked away with all the digital files and a single sixteen-by-twelve print (a combination not available in any standard package), the latter of which is still prominently displayed in the office of our grad school mom, Sanda.

In another demonstration of dubious maturity, we embroiled ourselves in a potato-sack arms race that spanned roughly a month, in which we spent nearly a thousand dollars on an impressive arsenal of Nerf guns — like the full-auto kind that take a couple of pounds of batteries. Things got so bad that, out of genuine fear of cornea damage, one eventually grew conditioned to wave a decoy of some sort to draw out snipers before leaving his room, and a backup sidearm was always stowed in the bathroom in case of ambushes (though it was wise to check ahead of time that the ammo hadn't been preemptively removed by conspiring attackers). If you're envisioning us scrambling around in a Lord-of-the-Flies–esque state of social decay, you'd be perfectly correct. Our eight-year-old selves, long since asleep within our unconscious minds, burst to the surface of our beings and cheered in triumph at this reckless wielding of grown-up financial independence. It was one hell of a good time.

Tropical Punch

In the fall of 2012, we received an email inviting us to an all-expenses-paid island resort. The senders wanted us to present a lecture and workshop at their conference, for which they would not only pay us actual money but

also cover our travel and lodging. The only caveat was that we would be expected to get drunk, sing karaoke, and do god knows what else with the other raving lunatics in attendance. The email was followed by a phone call from our soon-to-be lifelong friends Jen and Steve, hosts of the soon-to-be eye-opening What If, a conference intended to provide creative entrepreneurs with a meaningful experience and a sense of community.

We soon found ourselves in the balmy Dominican Republic, and, since we had been lucky enough to fulfill our official obligations early in the week, we figured we had nothing else to do but relax poolside and guard our fruity drinks from being spiked with whatever Kool-Aid the other conference goers seemed to be hopped up on. That plan was futile, of course, and we, too, became lost in the same hippie lovefest as everyone else. Among the many strange events which good taste begs us to omit from this book is our participation in late-night skinny-dipping in the resort pool. Every few minutes a new guard would arrive to shuffle up and down its edge as the offenders, combining every one of their remaining functional neurons in an impressive display of wit, drunkenly doggy-paddled to the opposite end in evasion. When the guards had clearly had enough, the party shrewdly seized the opportunity to gather their clothes and retreat to the beach, where some people distracted our pursuers by continuing their naked aquatic crime spree in the ocean while the rest of us escaped.

We learned early on that the people we were misbehaving with weren't just random entrepreneurs – many of them were among the top professionals globally in their respective fields. The significance of this revelation is in the lesson that being the best means giving yourself over completely not just to your job, but to life itself. We had the privilege of meeting people who understood how complicated our struggle had made our lives, yet who seemed to instinctively demonstrate to us exactly how simple life can be when you just let it happen. It's rare to meet one person who's really chasing his dreams, let alone anyone who's actually caught them, and here were dozens impossibly gathered together in the same place. We survived being culturally isolated for almost three years, but we'd found a community at last.

It's so easy to describe a life event as simply being *inspirational*, but it's so difficult to articulate just how it feels when something displaces your conceptions of yourself and your future, then squeezes everything out of you and fills you back up so fast that you immediately start to feel empty the second life stops flowing over the brim. Some people grab hold of you and never let go no matter how far away they are, and some adventures continue to carry you forward no matter how long ago they ended. We left the What If conference inspired to travel, and with the awareness that nothing prevented us from doing so except ourselves.

The fire of inspiration had been lit in us, and we had to let it spread. Our lecture series was the perfect opportunity to share the light, so, spontaneously, we decided to take it to the next level. Less than thirty days later, we bought a van on eBay and made arrangements for a two-month speaking tour across the country.

Pulling Out

Late summer in northern Ohio is a wonderful time of year. While the days are still warm enough for shirking responsibilities around apartment pools, the cool evenings are the perfect backdrop for lingering, long-sleeved whiskey talks. Proud old sycamores usher along muggy Lake Erie breezes in the final moments before their leaves yellow, redden, brown, and drop away. In Kent, these coveted pleasures, belonging almost exclusively to the university faculty and a few romantic townies, are as fleeting as the summer sun itself, because, hanging ominously over the horizon of the approaching fall, the crackling storm cloud of the returning student body promises a sixteen-week torrent of noise, insufficient parking, and public vomiting. And so, in August 2013, with little planning but much preparation, GFDA GTFO.

We packed up a van with matte black merchandise, a few supplies, and ourselves, full of piss and vinegar and ready for anything, to start a thirty-eight-city lecture tour of the United States. A selection of businesses, colleges, AIGA chapters, random strangers, and old friends would constitute waypoints on our dotted line across the map. Our chariot, our magic carpet, our mobile home, would be a nearly mint-condition, red, white, and gold 1972 Dodge B300 Sportsman van which we outfitted

with American flag seat covers. We collected our documentarian videographer (Danielle, or "Lil' Fatty" to her close friends), and the journey unrolled itself beneath our wheels.

As we traveled northwest, we passed under innumerable shades of pure blue that gradated together into a single thousand-mile-long painted postcard of rugged, beautiful landscapes, then braided a trail through miles and miles of sun-dappled, ancient redwood forests in our descent of the Pacific coast. We turned eastward, and the khaki and tan bespeckled desert terrain passed wearyingly across our view like an infinite loop of video. The van's terrible gas mileage made using the air conditioner cost-prohibitive, so we sweated our way into the cauldron depths of the Dirty South. Former mug box printer David joined up with us to share the wealth of his band tour experience. Like human roman candles, we blasted our sparkling personalities over university lecture halls, design studios, crowded bars, after-parties, hotel desks, restaurant counters, and everything in between for five straight weeks. David and Lil' Fatty kept spirits high with their monkeyshines as our route climbed up the East Coast.

Our engine, 360 cubic inches of classic American muscle, combined with the three-inch side-swept exhaust, gave the van a sensuous purr in idle, but a bone-jarring roar at cruising speed. A curb weight of almost four tons meant that it only accelerated past sixty at the cost of permanent hearing loss and about three gallons of gas per second. Conversation was impossible, and effective communication only came in the forms of pointing, shouting, and the occasional raised middle finger. The slow, monastically speechless quality of life inside the van (starkly contrasting our frenetic lives *outside* of it) was a sort of compulsory meditation, and forced us to be present in the moment as we traveled.

As we completed the final leg of our trip, returning to the Midwest, Brian's lovely parents attended one of our lectures, and looked on with pride as he laid out the story of our curse-word company in horrifying detail to a roomful of strangers. The next morning, eight weeks after we'd departed, we coasted back into Kent, our minds and bodies running on fumes.

Objects in Mirror Are Closer Than They Appear

We're often asked what compelled us, two young men fresh out of graduate school and buried under the stresses of running a business, to take on the months of hard work and terrifying risk of leaving our daily lives behind and set out on an exhaustive and costly fifty-three-day road trip.

Every city was a change of perspective. Every acquaintance was a new friend. Every day was a treasured memory. The stories are too numerous, and the profundity too great to be done justice here.

Why did we choose to travel the country? Go find out for yourself.

Form fo
fucking

lows
function.

If your work isn't setting the world on fire, maybe your process is lacking some spark. You can't do your best if you don't enjoy what you do. No one should settle for that. Set yourself in order. Then set your priorities in order. Then set your work in order. Then your life will have a sound enough structure to bear your dreams.

Live in the fucking moment.

Gather ye fucking rosebuds, because time doesn't give a shit about you. More than one hundred billion people have lived and died before you. Why should you matter? Cling as you might, you can't keep the past. Strain as you might, you'll never see the future. What you do have — all that you have — is now. And now, you're all that matters. Now is just for you. Live in this moment. Leave some evidence that you exist.

"Hold my beer" should be the preamble to all your endeavors. When your work is done, everyone watching should be saluting, setting off fireworks, or calling the authorities. Life is like a cage match; there is no second place. Line up those school buses, kick-start your creativity, and hit that ramp screaming your head off.

Be fucking bold.

3 AM

Stay up all fucking night.

There's a better way to lose sleep over your work than throwing a handful of Adderall in a blender with some Four Loko. Your passion should be keeping you awake at night, not your deadline. Light a fire in your heart, and your ass will catch.

00

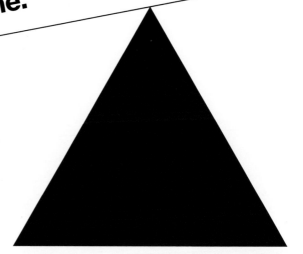

Nothing helps you get your head in the game like watching everything you've worked for teeter on the edge of destruction, but don't confuse having a gambling problem with having faith in your abilities. Discipline is the difference between risk-taking and recklessness.

FIND

FUCKING

Be the Sherlock Holmes of giving a damn. The clues to making your work better are hidden right in the open: you just have to piece them together. Maybe surrounding yourself with crumpled ephemera you found in the trash and sticky notes covered in hieroglyphs makes you look crazy (and maybe you are), but all that matters is finding the brilliant idea at the center

INSPIRATION

EVERYWHERE

do what you

fucking love.

Carve your own fucking path.

Don't follow the well-trodden way. That adventure is all used up; the treasure is long gone. Turn into the weeds and climb over the problems others have chosen to go around. It's supposed to be difficult and frightening; you're supposed to get lost. That's the point.

Know what you're fucking worth.

Did someone tell you you're too expensive?
Take it as a compliment. Expertise comes at a
premium, not a discount. You're a commodity:
sell high.

$$$

Money isn't fucking everything.

Be more than your billable hours. Don't waste the best part of yourself by taking on work you don't believe in. You're not a commodity: don't sell out.

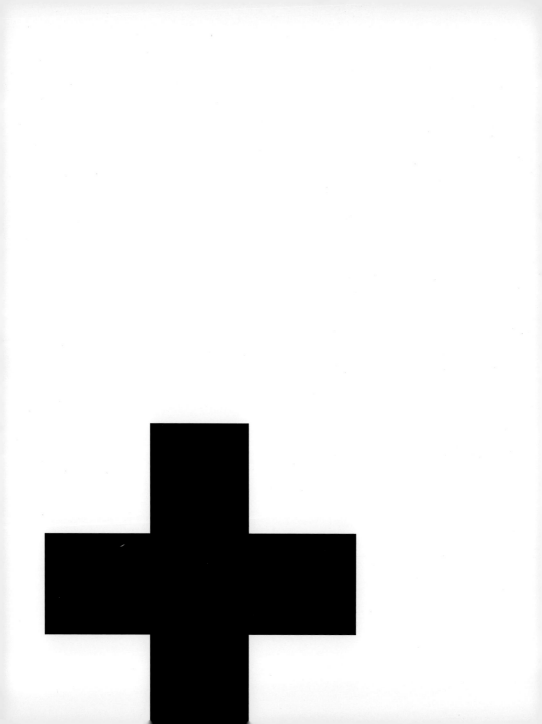

Show some fucking passion.

Constantly fucking challenge yourself.

The point of playing the game is to get better at it. Set the difficulty to hard. There's no manual, no bonus levels, and no pause button. The Konami Code won't work. You don't have any extra lives, and you can't hit reset. You have to put in the hours and keep your health-bar full. Save your grenades for the boss fights, and strive to beat your high score every damn day.

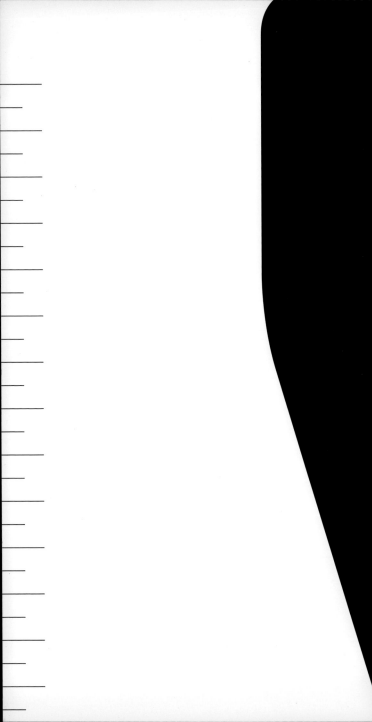

Fucking experiment.

Genius hides itself in unexpected places; you have to be willing to try anything. The only way your experiment will fail is if you don't try to understand the results. Even when you get it wrong, you're still getting it right. Throw on a lab coat, fire up some centrifuges, and keep going until you see the meaning in the experience.

~~Surprise~~ your

Every small win is an opportunity to reinvest in yourself. You might just be that big break you've been waiting for. Keep a couple of baby aspirin ready, because you may have a heart attack when you see what you've been hiding.

fucking self.

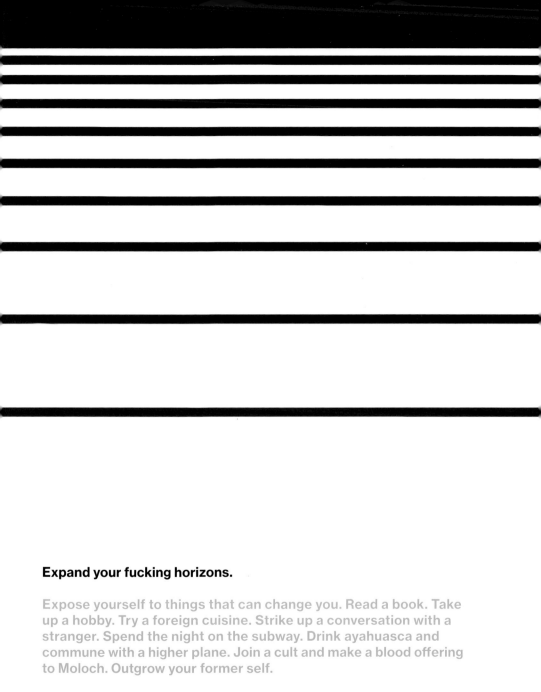

Expand your fucking horizons.

Expose yourself to things that can change you. Read a book. Take up a hobby. Try a foreign cuisine. Strike up a conversation with a stranger. Spend the night on the subway. Drink ayahuasca and commune with a higher plane. Join a cult and make a blood offering to Moloch. Outgrow your former self.

Start a fucking side project.

There's nothing wrong with getting a little piece on the side. You deserve to skirt the line between work and play every once in a while. There's plenty of you to spread around. It's a waste to keep all that passion stuck in one place. Besides, it's always good to have something to fall back on.

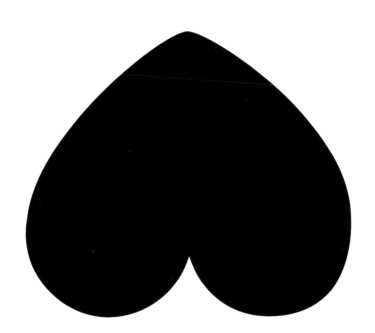

Respect your fucking self.

Yes,

you.

Finish the fucking job.

Starting GFDA meant doing the impossible, and surviving this long has been nothing short of a miracle. After all that, we're not closing up shop anytime soon, but we have found higher mountains to climb. So we have to leave behind what we no longer need. The greatest power in the world is the ability to let go. For us, finishing one thing always comes in the form of falling ass backward into something new. That's been just as true for our friendships as for our business development. We're absolutely certain that the end of this story marks the beginning of our next adventure.

Trial Separation

Those who would stay in some small place their whole lives, never entertaining a moment's curiosity for the exotic and the unknown, and then be judged harshly for it, may be judged unfairly; perhaps they limit their horizons not out of fear and ignorance, but out of a higher wisdom that spares them the suffering of falling in love with some other place, or people, or some other way of life that they unconsciously know they would never have the freedom to fully embrace nor the will to let go of. The tour, having filled our senses and our circle of friends to the bursting point, somehow managed to leave us with a certain feeling of emptiness upon our return home, and wanting something that we couldn't quite put into words. Holes had been poked in the low roof of our lives, and it wasn't

the gray skies of northeastern Ohio that shone through, but the brilliant, penetrating light of new experiences, betraying every dusty corner of our little world. Never before had the walls seemed so close, the colors so dull, and the windows of our post–grad school existence so narrow. What gremlin resides deep within the machinery of the human spirit that plagues it with dissatisfaction at seeing any foreign wonder, any beauty, any glinting treasure, and then leaving it untouched?

The decision to take the tour had come on quickly, practically forming itself. This was different. It wasn't a call to action — it was a crossroads. There were many ways forward, many new vistas, but from our vantage none seemed distinct. Several long conversations ensued. In the end, we decided we had to take a big step and, yet again, put everything on the line. For one year, we would test GFDA's resilience under a decentralized model by working from different cities. And so, after twenty-eight years of living in Ohio, Jason was going to strike out on his own to find new business, while Brian ran operations in Kent.

In the three days we spent in New York on the tour, especially after weeks of living in a van, the city didn't leave a positive impression on us. Doing practically anything there is a pain in the ass that will cost money and piss someone off in the process. It didn't seem like the sort of place where anyone could reside and then ever again be able to look upon the rest of mankind with a favorable opinion. On the other hand, we did have the objectivity to see that New York had huge potential to expand our reach and refine the culture of our brand. With headquarters fully intact back home, we had a safety net in place in case we overextended ourselves. Besides, doing things the easy way just isn't our style.

Bada Bing

Forging GFDA had honed Jason's instincts and allowed him to build his stamina, and New York would be the ultimate test of what he was made of. It requires hard emotions to thrive in harsh environments, and Jason wasn't prepared for just how long it would take to build a personal network.

The context that GFDA would assume under these new circumstances was equally unclear. The move couldn't just be a journey of personal discovery; the decentralized experiment had to produce measurable results. Jason hustled. He had lunch with everyone, visited everywhere, and absorbed everything. He gained behind-the-scenes access to organizations of all sizes and unfiltered insight from people at all strata of success: studio-apartment entrepreneurs, those who had made the evolutionary leap from start-up to small business, those who had seen the view from the top and decided to leave it all behind. By exploring the journeys others had taken, it became possible to glean where GFDA could go and reflect on where it had already been. Jason, whose fascination with the art of the sale is insatiable, had struck gold. Within a few months, his trajectory stabilized, and opportunities for collaboration began to bloom.

One such connection came from the proprietors of BEAM, a Brooklyn retailer that offers all the necessary accoutrements for a well-curated designer lifestyle. As one of our long-established wholesale customers, they offered Jason a rare chance to see our products displayed on store shelves. The stark colors and Swiss type treatment caught people's eyes, and the frankness of our message bent their ears. It made them stop and pay attention and actually form an opinion of what they saw.

We partnered with BEAM on a number of projects, including using their venue to collaborate with type designer Ricardo for New York Design Week (which resulted in a series of four-by-six-foot hand-drawn posters), and a pop-up booth at the Union Square Holiday Market that was a smash hit. We also redesigned BEAM's brand, and, among other impressive positive outcomes, just one year after the project they saw over a 300 percent increase in online sales alone.

Other New York partnerships, escapades, conquests, mistakes, and dead ends are far too numerous to recall, let alone list here. Those yet unexperienced are, hopefully, even more numerous. It's been said that one is no more a New Yorker in a lifetime than he is in five minutes, and even after all these years, Jason feels like he's just scratched the surface.

Meanwhile, Back at the Ranch

With Jason gone, Brian now ruled the Windchimer roost uncontested except for the *other* Jason, whose mild temperament and winning personality made him a model housemate (and writer of this book). Brian's first order of business was to transcend the status of basement dweller by occupying the master bedroom and converting his old room into a full-on photography studio. GFDA had finally consumed the entire basement.

By this point we were operating at peak capacity and shipping products all over the world. We now had three employees and an intern. Every other week an eighteen-wheeler would park in the middle of the street in our residential neighborhood and off-load pallets of products and supplies onto the sidewalk, which would then be carried in piece by piece by any able bodies unlucky enough to be home. Looking back, it's a miracle that we managed to get away with it all. By sheer luck, we were just close enough to a column of Kent State's notoriously rowdy, filthy fraternity houses to be invisible to the authorities.

Keeping all that mayhem in some semblance of order was a full-time job. As long as we had to process orders ourselves, Brian would be tied to the Kent headquarters. He began to envision a dismal future in which he withered away alone in a college town into retirement, recruiting a new batch of misfits every few years to replenish those who'd graduated, frisking them every day for stolen toilet paper and printer cartridges. He had to hire a fulfillment service while his sanity still held, which would prove to be deceptively yet predictably difficult. After pursuing a handful of dead ends, the process became somewhat formulaic: a sales rep would promise us a long romance and assure us he'd reach out in a few days with some numbers. Then we'd receive a call from the CEO, explaining that they just couldn't in good conscience expose their employees to the profanity. Swearing in movies, television, music, social media, and basically the entire internet was all okay, but a coffee cup? Madness. The fabric of society is simply too delicate to withstand such a strain.

It's perfectly reasonable to identify our brand as a potential HR issue, but being rejected in the name of casual morals was getting old. Eventually,

Finish the fucking job.

however, Brian's persistence paid off and he found a company in Florida that would roll posters, fold shirts, and double-box those volatile mugs.

You Don't Have to Go Home, but You Can't Stay Here
Securing the fulfillment center just so happened to coincide with the successful completion of the year-long decentralization experiment, the graduation of all our employees, and the end of our lease. We loaded up a Florida-bound semi with screen-printed f-words; Jason packed the flat files and shelving units into a U-haul to give his tiny New York apartment even less livable space; and all Brian's worldly possessions (about seven hundred martial arts books and karate uniforms) were crammed into his midsize sedan. After much hugging and crying, we said our painful goodbyes to the people we'd come to rely on and love like family, and took one last look at the house. Since second-degree arson is a felony in the state of Ohio, we decided not to attempt to protect the Windchimer legend from future tenants by burning it down. (The kids who moved in after us totally trashed the place, of course. Fuckers.)

We'd matured past the challenges of running the business day-to-day, and new adventures were calling. It was time to turn the page.

Lightning in a Bottle
Way back in 2011, our friend Ruki had the foresight, good taste, and questionable judgment to invite us to a small, conservative university in Oklahoma to swear at her students and the local design community. This first-ever speaking engagement ended with a standing ovation, a handful of lasting friendships, and a three-figure paycheck (a monumental windfall at the time).

Since then, we've armed the rebellion against the status quo at sixty-eight events in eleven countries on three continents. We've been on a domestic tour of thirty-six states and an international tour of seven European cities.

Our lecture series had humble beginnings, and we continue to be humbled by the investment that our audiences are willing to make in our message. The power of the GFDA brand has always lain in the connection that

people make with it, and our mission has always been to inspire them to exceed their limits. That mission has transcended its original digital incarnation and risen up to something much more powerful, and now we're following it to new heights.

The current iteration of the GFDA experience (disguised as non-f-word-incorporating "The Art of Risk-Taking" workshop series) finds us teaching folks behind household brands, international conferences, and small businesses alike to retain the baby of creativity as they throw out the bathwater of control. We've offered our workshop to corporate executives, business managers, art directors, interns, and everyone in between. They all employ creativity (or rely on someone else's) to do their jobs; and they all report back with verifiable gains in productivity and stronger cultural identity, after learning to let go of their egos and work together to finish what they fucking started.

Creativity is only useful because it can't be controlled, and what comes of it is only valuable because it's unpredictable. If the answers could be known from the outset, no one would seek expertise. If the landscape of creativity were already charted, no exploration would be funded. The unknown is threatening: it conceals dangers for which we may not be prepared and reveals no clear way to safety. Every day of our lives we're called to take that journey, to face those unforeseen threats, and to be lost along those untrodden paths. The journey *must* be treacherous, the way *must* be unclear: danger and uncertainty are prerequisites to meaningful accomplishment.

Dreaming is fundamental to the human experience. It gives us a glimpse of our potential as individuals and a vision of the infinite possibilities that arise when we work together as a community. That potential is invaluable, but it's worthless alone. Empires aren't built on aspirations; they're built on hard work and no small degree of sacrifice. Potential must be manifested – the materials purchased, the tools taken in hand, the craft refined – in order to turn dreams into reality and castles in the sky into a city skyline.

Finish the fucking job.

Building GFDA has been a lot of fun, but that's only one part of the formula. Every time we've exceeded an expectation, passed along a piece of knowledge, or picked ourselves up off the mat, we were able to do so because we took risks and followed through to finish the job. Most of our successes came within a hairsbreadth of failure because we earned the confidence to push boundaries. Investing in our educations, believing in ourselves, showing passion, asking for help . . . that isn't just coffee-mug fodder – it's the difference between calculating risk and being reckless with our careers.

BE.
FUCK
DECIS

He who hesitates is lost. Even if your destination is unknown, you have to choose your direction. Be open to outcomes, not attached to them. Your future might be undecided, but taking the first step has to be your decision. Own it: sometimes that's all life is going to give you.

KING.
SIVE.

The details make the fucking design.

Small changes accumulate into large effects. There's only a 0.1 percent variation in DNA between you and the worst person you've ever met. When's the last time you were absolutely certain that you got something 99.9 percent right? How about 93 percent? Because that's how similar you are to the worst rhesus monkey you've ever met. Scrutinizing the details can be the difference between grasping a concept and throwing poop.

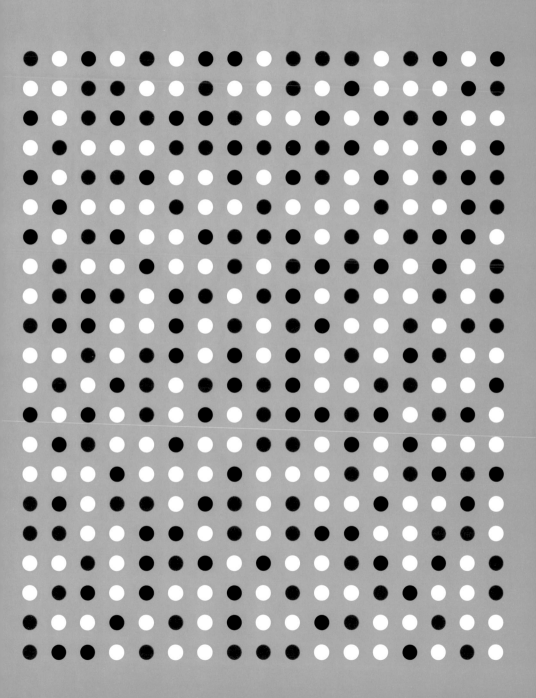

Never miss a fucking deadline.

Because it sure as hell isn't going to miss you.

Commitment requires fucking sacrifice.

To get something out of your work, you have to give up your time and effort. To get something out of your dreams, you have to give up much more. You have to give up comfort, vulnerabilities, and inhibitions. You have to give up being right. Succumbing to fear might protect you from known dangers, but it will also rob you of unimagined benefits.

A: POSSIBILITIES
B: DANGER

Don't fucking procrastinate.

Leave nothing to fucking chance.

Life can be a crapshoot, but you can load the dice. Bad things happen to everyone. Everyone fails. Everyone misses a critical detail. Prepare yourself. Be nimble. Sharpen your focus. That way, when you eventually wind up on your ass, you can't be kept down.

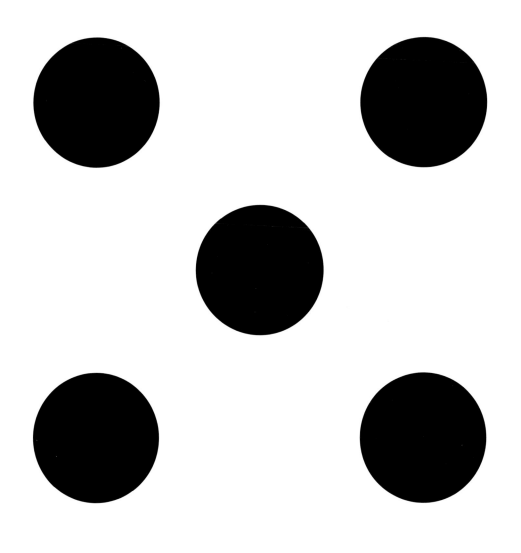

No one is going to fucking do it for you.

This is your world to conquer, your living experience to create. It's your rite of passage — don't let fear and uncertainty rob you of it. Find your own way. Charge recklessly into the thickest part of the wastes. Fight the terrible dragon — the threat must be real, and it must be deadly. Kill the old gods and steal their light. Shed your dependency and live by your own means.

Never fucking settle.

If you want something great, you should expect to pay a great price, put in great effort, and spend a great amount of time. If you don't have enough to invest, save up. Don't waste your potential on low-hanging fruit. Anyone can accomplish that. You can do better. Hold yourself to a higher standard.

Ten
Nine
Eight
Seven
Six
Five
Four
Three
Two
One
Done. ✓

Learn when to fucking compromise.

If you can't get a 10, having an 8 is still pretty good. If you can't get an 8, be grateful to have a 5. If you can't get a 5, have a few drinks and take whatever comes along.

Exceed the fucking expectations.

Be the surpris
in that rder o

e onion ring
f french fries.

Finish your fucking degree.

It's not about a piece of paper; it's about a piece of your life that deserves to be fulfilled. When you've given that much time and money to anything, finishing what you start is more than acting on principles—it's an act of personal responsibility. Don't give up; we're rooting for you.

Keep your fucking promises.

You can be committed without getting locked up. Sometimes following through requires running around in the middle of the night in your underwear. Prove that you meant every word you said, even if you were talking to yourself. You know your idea is the right kind of crazy when people start trying to hold you down.

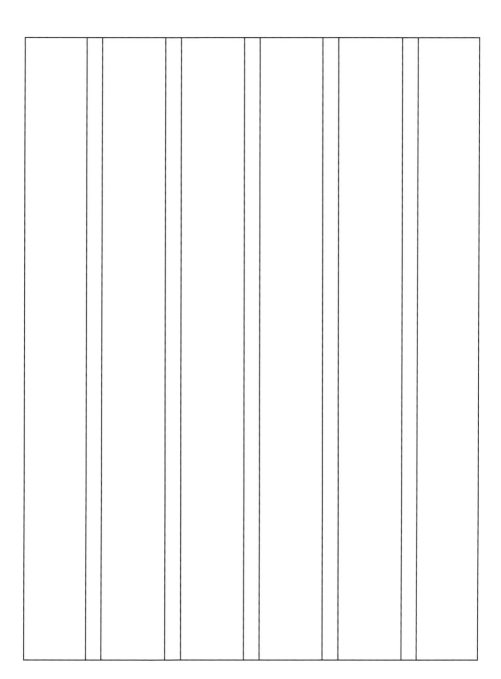

~~Fucking~~ simplify.

Make your work fucking meaningful.

The sole purpose of your existence is to bring the light of meaning into the world. The human condition afflicts us all, and each of us is obliged to strive for a meaningful contribution. You may work to move the whole thing forward or set it back, but no one has the option to sit it out. We're all in this shit together.

Pass along your fucking knowledge.

Finish the fucking job.

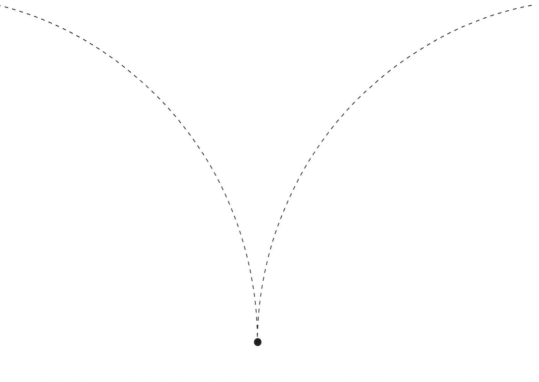

If the Mayans hadn't done their due diligence in studying astronomy for thousands of years, creating a pictographic language, and chiseling their findings into stone, we'd all have been totally unprepared for the end of the world back in 2012. Even if you're wrong, your experience might help the next poor soul get themselves together.

Don't hold the best of yourself in reserve. Throw it into the fire. There is no final push. There is no end. Your creativity is boundless and so are you. All you'll see from the mountaintop are new mountains.

ha
requir
Mastery

work.
fucking
rd
es

Show some fucking gratitude.

Never forget the people who have helped you along the way (and, if you can, put their names in a book). Thanks to:

William Alfonsi
Ali Arain
Debra Bacher
John Bacher
John Ryan Bacher
Katelynn Bacher
Anne Barlinckhoff
Gayle Basinger
Jen Bebb
Steve Bebb
Hadar Ben-Tzur
Keith Berger
Nathan Blazek
Mike Bockoven
Ryan Brannon
John Brett Buchanan
Betty Buirge
Dianne Buirge
Morey Buirge
Tim Buirge
Bonnie Burke
Christina Campbell
Donna Carlton
Ivan Cash
Michael Cassidy
Alex Catanese
Archie Lee Coates IV
Greg Coccaro
Tim Collingwood

Michael Cooper
Ed Cunliff
John Custer
Matt Dayak
Toti Di Dio
Brito Diego
Ryon Edwards
Logan Emser
Emma Fagan
Chris Faykus
Ernie Fesco III
Jody Feso
Marianna Fierro
Anita Francisco
Nikki Frank
Steve Frank
Susan Frank
Eddy Gan
Cristina Garces
David Geddings
Diane Geddings
Peter Giffen
Molly Girard
Ryan Girard
Doug Goldsmith
Jason Goupil
Lauren Haase
Dean Haddock
Ruth Hamilton

Rachel Hellgren
Michael Hines
Jessica Hische
Rob Hunt
Joan Inderhees
Jonathan Ive
Brian Kaiser
Jerry Kalback
Robert Kane
Sanda Katila
Bob Keleman
Lokesh Khemani
Barnett Klane
Bill Krowinski
Lisa Krowinski
Peni Acayo Laker
AnnMarie LeBlanc
Judy Lewis
Roger Lewis
Josh Liberson
Bob Lindgren
Linda Lindgren
Jim Ludwig
Mina Ludwig
Katie Lyall
Tom Mahon
Chris Majcher
Erin Marvinney
Victor Mathieux

Show some fucking gratitude.

Ralph Matthews
Eric May
Bob Melvin
David Middleton
Danielle Miller
Mike Mistur
Toby Morris
Nate Mucha
Shelby Muter
Tom Neighbarger
James Nesbitt
Tara Nesbitt
Marc Newson
Kevin Oberle
Katherine O'Kelly
Pete Popivchak
Christopher Ransom
Ruki Ravikumar
Valora Renicker
Nick Rhodes
James Richburg
Tammie Richburg
David Robins
Dan Rock
Eric Ross
Dan Rugh
Sarah Rutherford
AJ Sabino
Ricky Salsberry

Bill Schmitz
Ruth Schmitz
Joel Schroeder
Mary Schroeder
J.E. Shorter
Ruth Shorter
Lauren Slusher
Nate Smith
Laura Smous
Mary Snodgrass
Jenny Solar
Josh Solar
Dylan Steinberg
Charlotte Stockdale
Mark Strimple
Larry Thacker
Sara Thomas
Jason Tiberio
Steve Timbrook
Carla Torres
Chris Torrey
Marius Valdes
Terry Valentino
Virginia Valentino
Monika Verma
James Victore
Laura Victore
Jenn Visocky-O'Grady
Ken Visocky-O'Grady

j.Charles Walker
Maya Washington
Terran Washington
Todd Wendorff
Larkin Werner
Jim Williams
David Wilson
Nick Wilson
Michael Wolaver
Lauren Woods
Brian Zimmerman
Gina Zimmerman
Shane Zucker

About GFDA
Founded in 2010, Good Fucking Design Advice is a Pittsburgh-based studio that helps organizations with quarterly budgets great and small realize crazy dreams, accomplish impossible goals, and harness the power of culture by taking the right creative risks. We've been invited to destinations around the globe to share the wealth of our experience in client initiatives, lectures, and workshops. We're available any time to talk shop or just shoot the shit, so don't be shy.

studio@goodfuckingdesignadvice.com
www.goodfuckingdesignadvice.com
@GoodDsgnAdvice

About the Authors
Jason Bacher co-founded GFDA while earning his MFA in Visual Communication Design from Kent State University. He is currently an independent creative director in Brooklyn, NY.

Brian Buirge co-founded GFDA while earning his MFA in Visual Communication Design from Kent State University. He is currently the owner and creative director at GFDA.

Jason Richburg suffered the founding of GFDA while earning his MFA in Visual Communication Design from Kent State University. He is currently the curriculum director and copywriter at GFDA.

Pictured (left to right): Jason Bacher, Brian Buirge, Jason Richburg

Photo: Matt Dayak

Index

F

Fucking: 2, 3, 5, 6, 7, 11, 12, 13, 14, 15, 16, 17, 19, 20, 22, 24, 26, 28, 30, 32, 34, 37, 38, 40, 42, 44, 45, 47, 49, 51, 52, 53, 54, 55, 56, 57, 58, 60, 62, 64, 65, 66, 68, 69, 70, 72, 74, 75, 77, 78, 79, 80, 81, 82, 87, 90, 92, 95, 96, 97, 98, 99, 100, 101, 102, 104, 105, 106, 108, 110, 112, 114, 116, 119, 120, 123, 124, 126, 129, 130, 131, 132, 133, 134, 137, 138, 139, 140, 141, 142, 145, 146, 149, 150, 152, 155, 156, 158, 160, 162, 164, 167, 168, 170, 173, 174, 175, 176, 177, 178, 179, 180, 182, 184, 185, 186, 188, 190, 193, 194, 196, 199, 201, 203, 205, 207, 208, 210, 213, 214, 215, 216, 217, 218, 219, 220, 222, 224, 226, 229, 230, 232, 234, 235, 237, 238, 241, 242, 244, 246, 248, 249, 251, 252, 253, 254, 256